Eric Homan & Fred Seibert

present

original cartoon
TITLE CARDS

from Frederator Studios

The unconsidered art
of the cartoon title card.

For almost a century, the art of the cartoon title card has not been disparaged, disregarded, or dismissed. It has been completely ignored. And by the 1970s it had almost completely disappeared. So, it was no easy task to find someone who could write the introduction to this book of Frederator Studios' title cards. Maybe on the internet there was someone with a writer's eye who had a few choice words to say about decades of cool illustration and graphic design?

Nothing.

There are several places that display beautiful vintage cartoon cards, usually for filmographic or historical purposes. But, for all the pages devoted to critical analysis and display of another pop culture icon, the movie poster, there wasn't a full paragraph of consideration that turned up about the kind of art we've got in this book.

Well, I'm no art historian, so there won't be any scintillating examinations here. Just let me point out that it might be worth checking out the dozens of talented artists and creators who have shared their work with us. All sorts of styles are represented, from homage to the one and two color cards we saw in the silents, to sumptuous, nuanced illustrations that are hard to appreciate in the 10 seconds they're usually displayed on television. Breadth of craft is also demonstrated here, from simple typography, pencil on paper, computer generated images, even paper cut outs.

Within minutes of ruminating about cartoons for the first time --professionally, that is; they probably started dominating my mind as soon as my parents got their first TV-- there was no choice. The model for my productions needed to be the great shorts during the golden age of the early, mid-20th century: Looney Tunes, the Disney's, the MGM's, even the first TV shows of Hanna-Barbera. And there was no joking about the template. Our films would hew as close as possible to these classics from front to back. Beautiful titles with the studio logo, character name, episode name, seven minutes of

squash & stretch hilarity, and "The End." No deviations, please.

It took a few years to get anyone to agree that we could even make these kinds of cartoons (thank you kindly, Scott Sassa and Ted Turner). And, among the creative posse making the first 48 shorts there wasn't one push back about the idea of the title cards, they loved everything cartoon. It helped that I was the president of the studio, but that really had nothing to do with it.

The talent we'd lined up were champing at the bit to reintroduce --no, reinvent-- the very idea of cartoons, since the production industry and the networks had almost completely abandoned the form almost 30 years before. Disney had long seemed embarrassed by their 'cartoon' roots, but even the 1980 revival of the famous Warner studio couldn't admit their strength and named itself "Warner Bros. Animation." Our team trained themselves in a business that had turned its back on their love, but they were undeterred. When we announced our complete dedication to the form, they lined up in force and embraced every aspect of our program, eventually creating a tidal wave of success that made cartoons the dominant form of animation throughout the 1990s and 2000s.

The networks were another story. It's fair to say that we've had resistance to title cards for almost every one one of the almost 20 series that have been sprung from our three shorts series of the last 15 years. It's never the budget issues, which would have been my first arguments against them, if I'd been

so inclined; it is not inexpensive to make between 50 and 150 of illustrative, finished artwork per season. No, unfortunately, there's probably a failure of imagination. "Other series don't do it."

Cartoon title cards indeed seem to be an unconsidered art, at least everywhere else. Everywhere but here. This art is no longer ignored, so please feast your eyes for as long as you might wish. I guarantee some gorgeous rewards.

Fred Seibert
New York, 2011

*Fred Seibert founded
Frederator Studios in 1998.*

From "Mind the Kitty," created by Anne Walker, for Random! Cartoons

What A Cartoon!
1995-1998

Created by Fred Seibert
Title card art from video grabs
for cartoons by
Ralph Bakshi, Miles Thompson, David Feiss, John R. Dilworth,
Genndy Tartakovsky, Joe Barbera, Pat Ventura, Butch Hartman,
Michael Ryan, Bill Hanna, Bruno Bozzetto,
John McIntyre, Van Partible, Seth MacFarlane, Rob Renzetti,
Craig McCraken, Robert Alvarez, Joey Ahlbum

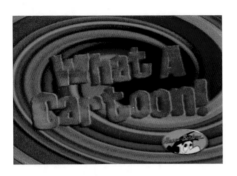

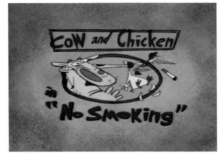

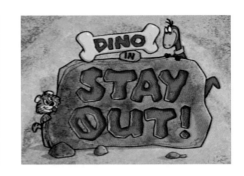

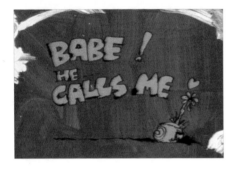

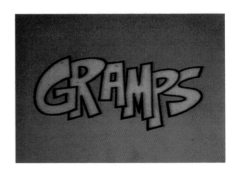

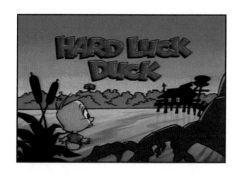

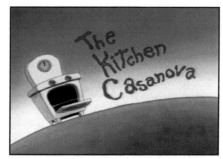

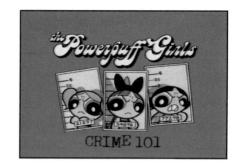

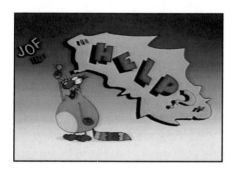

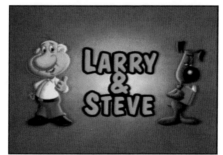

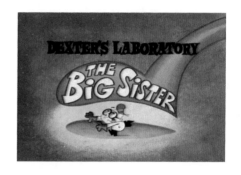

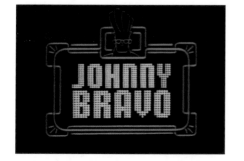

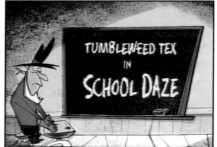

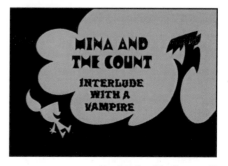

Oh Yeah! Cartoons
1998-2002

Created by Fred Seibert
Title card art from video grabs
for cartoons by
Seth MacFarlane, Carlos Ramos, Mike Bell, Miles Thompson,
Bill Burnett, Larry Huber, Pat Ventura, Rob Renzetti,
Dave Wasson, Byron Vaughns, Harvey Kurtzman,
Vincent Waller, Tim Biskup, Butch Hartman,
Steve Marmel, Antoine Guilbaud, John Eng

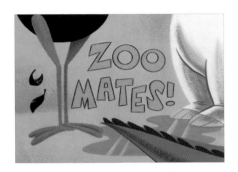

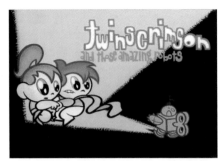

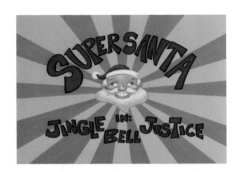

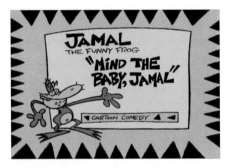

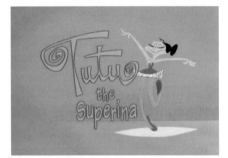

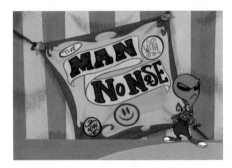

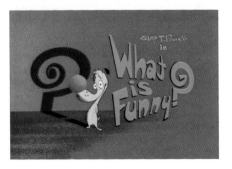

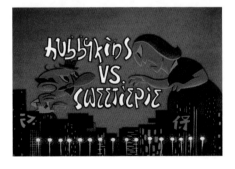

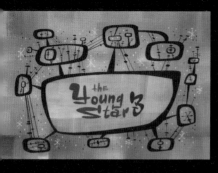

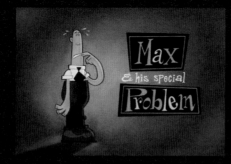

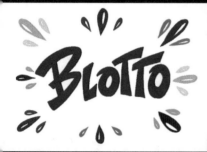

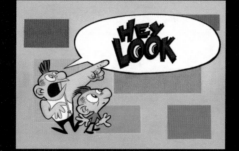

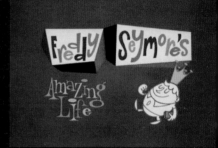

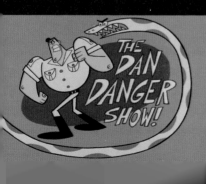

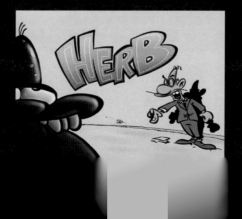

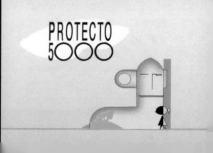

The Fairly OddParents

2001-2010

Created by Butch Hartman
Title card art by
Andy Suriano, Bob Boyle, Teri Shikasho,
Dan Chessher, George Goodchild, Ernie Gilbert,
Gordon Hammond, Nadia Vurbenova-Mouri,
Honore Gauthier, George Taylor, Frank Rocco,
Holly Kim, Mike Dougherty, Kristin Donner

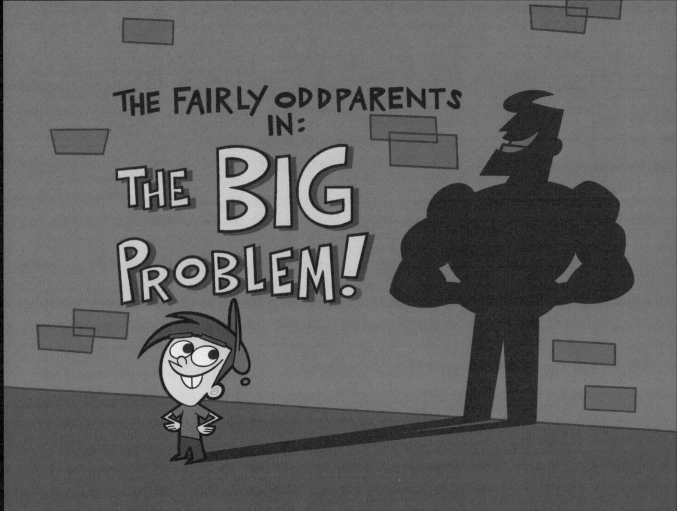

The FAIRLY ODDPARENTS in:

"Shiny Teeth"

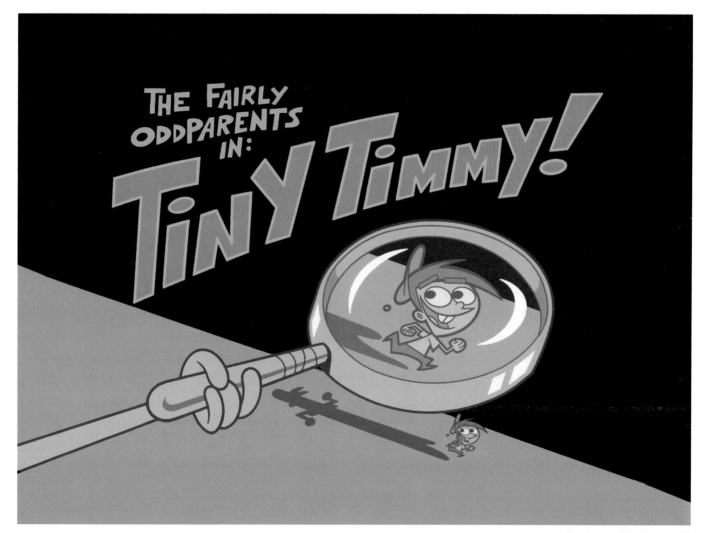

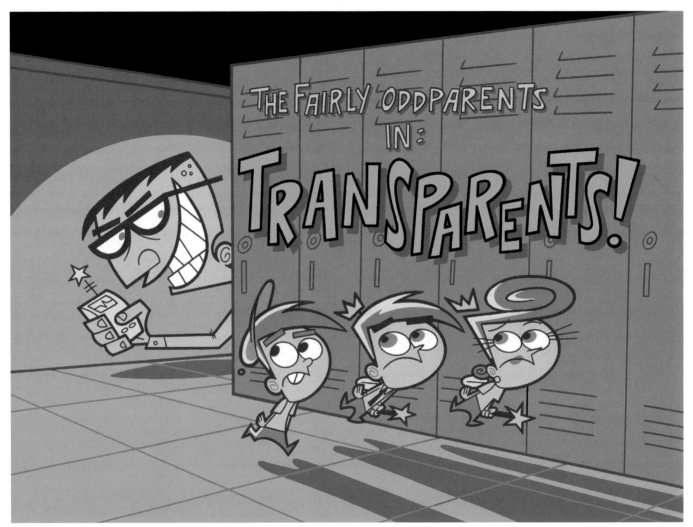

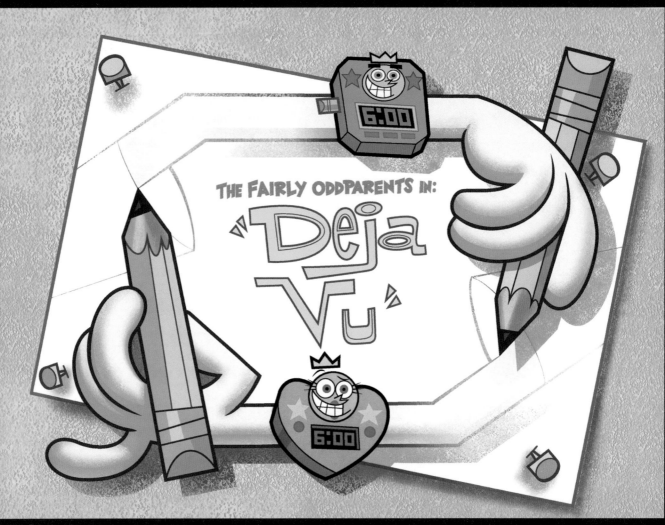

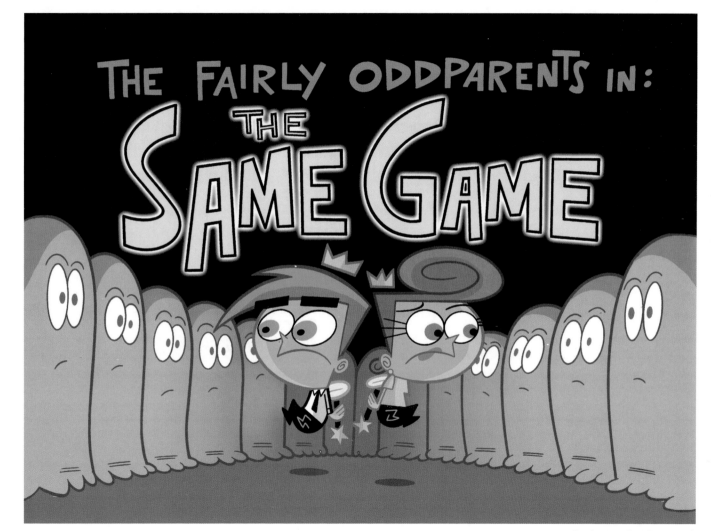

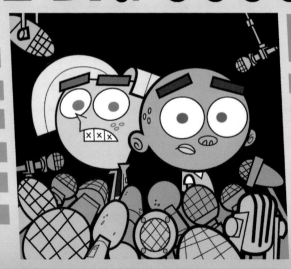

The FAIRLY ODDPARENTS in:

"THE BIG SCOOP!"

The FAIRLY ODDPARENTS in:

TEETH FOR TWO

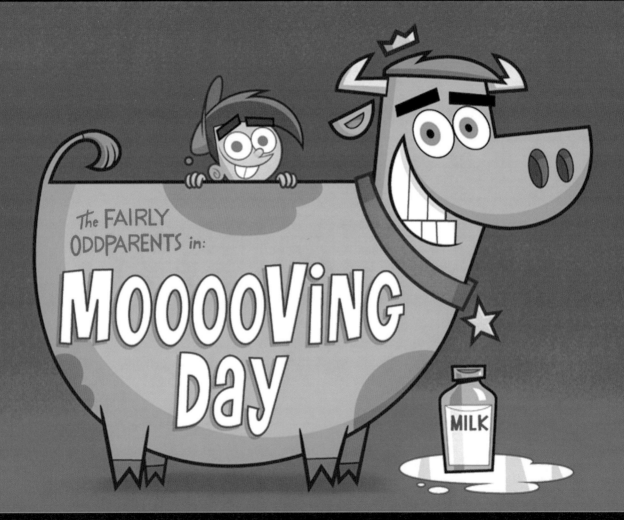

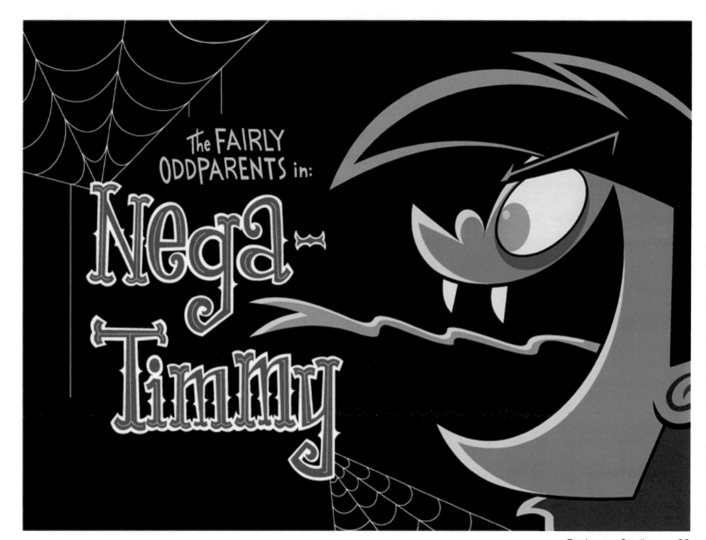

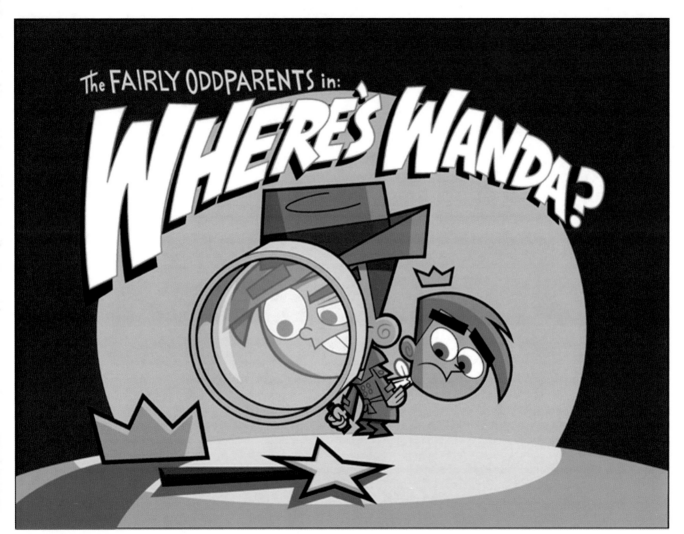

THE *FAIRLY ODDPARENTS IN:*

BAD
HEIR
DAY

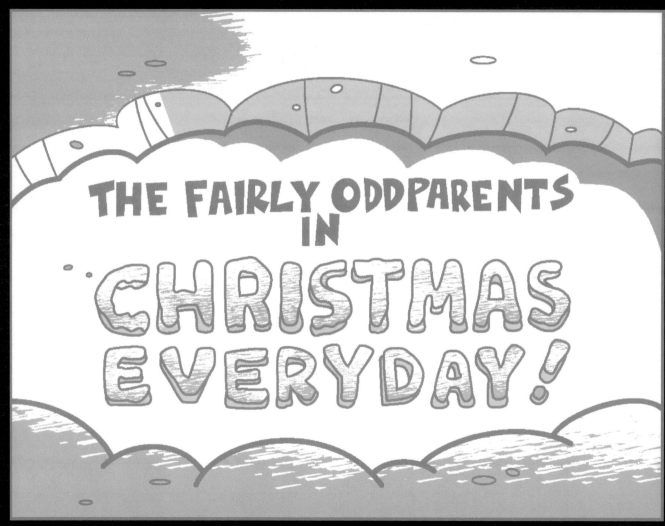

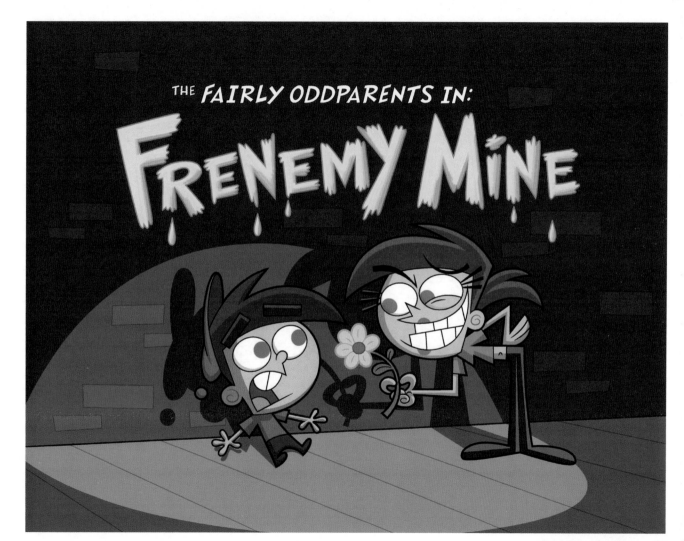

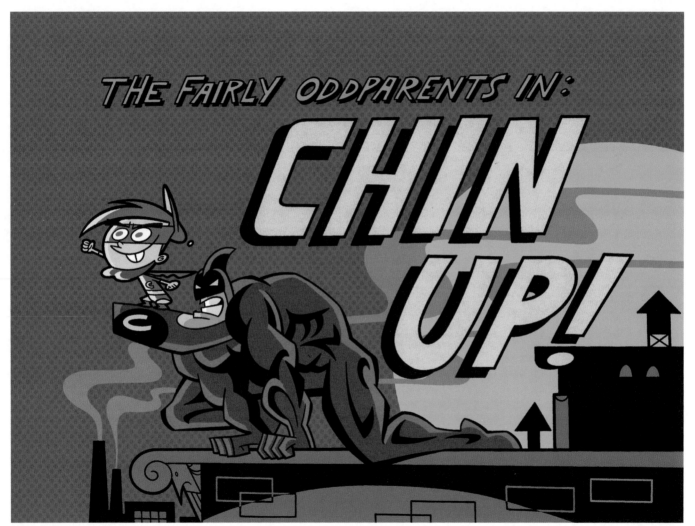

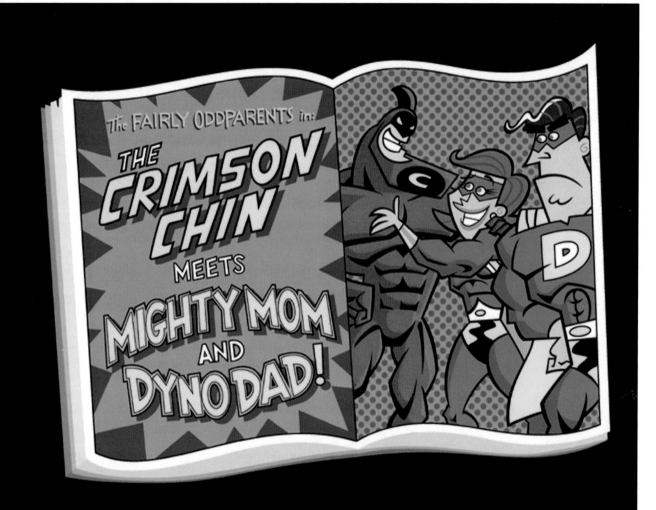

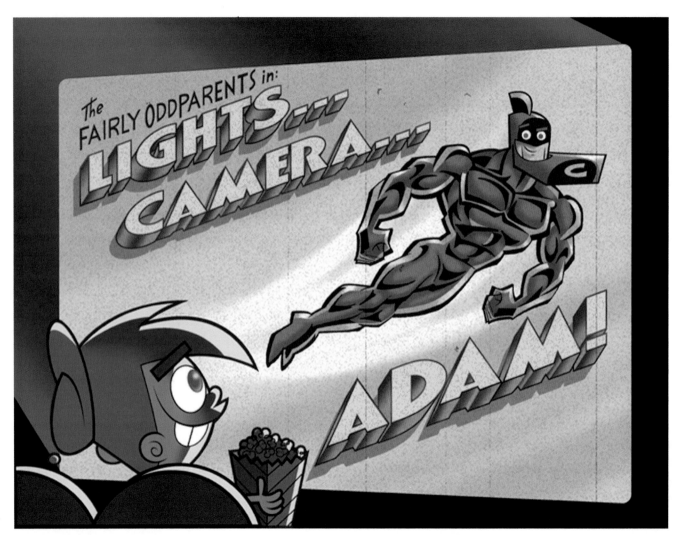

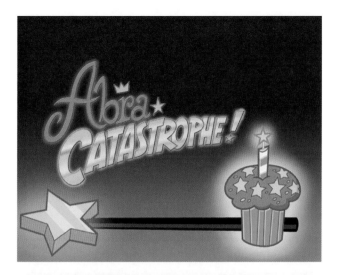

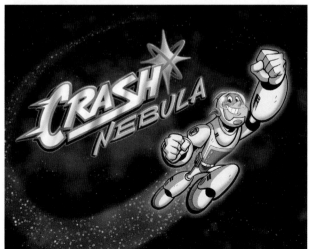

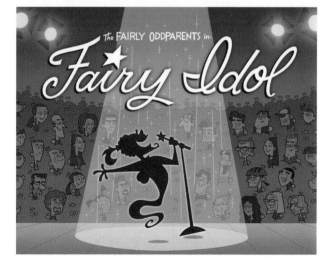

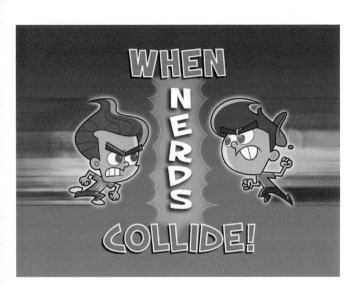

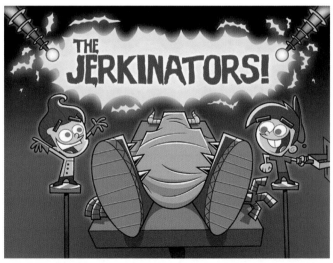

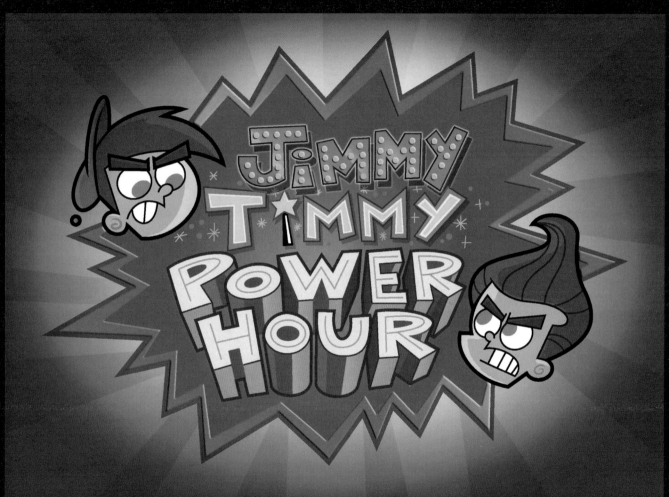

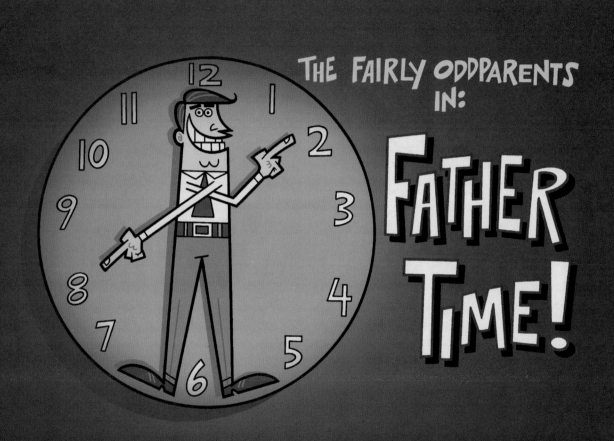

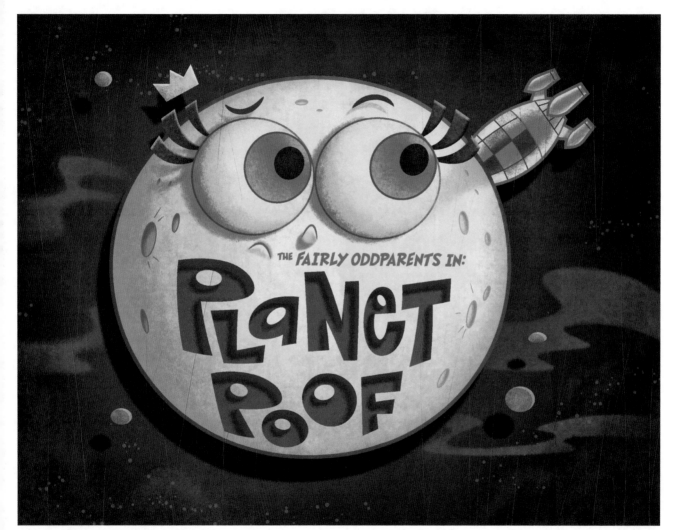

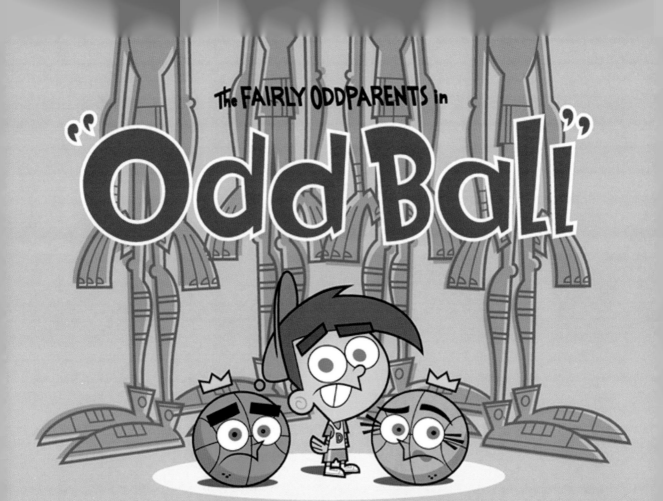

THE "GOOD OLD DAYS!"

A FAIRLY ODDPARENTS CARTOON!

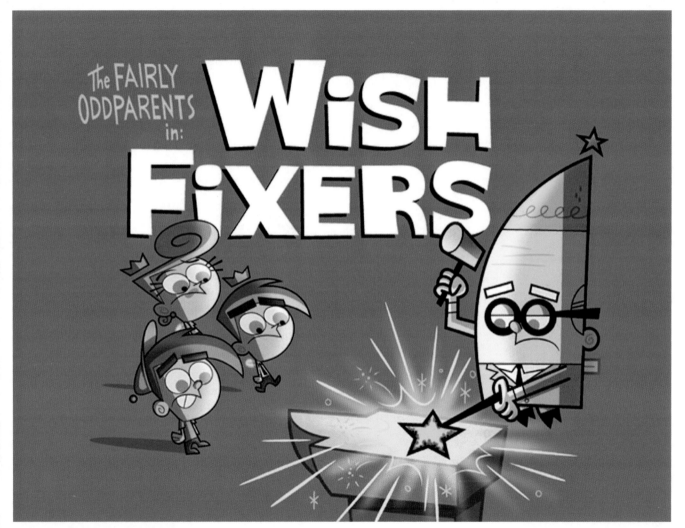

THE FAIRLY ODDPARENTS
IN:
"Fairy Fairy Quite Contrary"

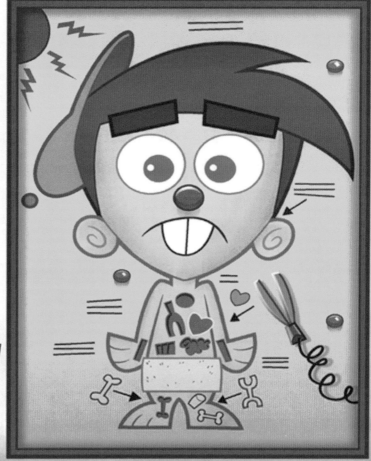

THE
FAIRLY ODDPARENTS IN:

OPEN WIDE and SAY AAAGH!

ChalkZone

2002-2005

Created by Bill Burnett & Larry Huber
Title card art by Guy Vasilovich

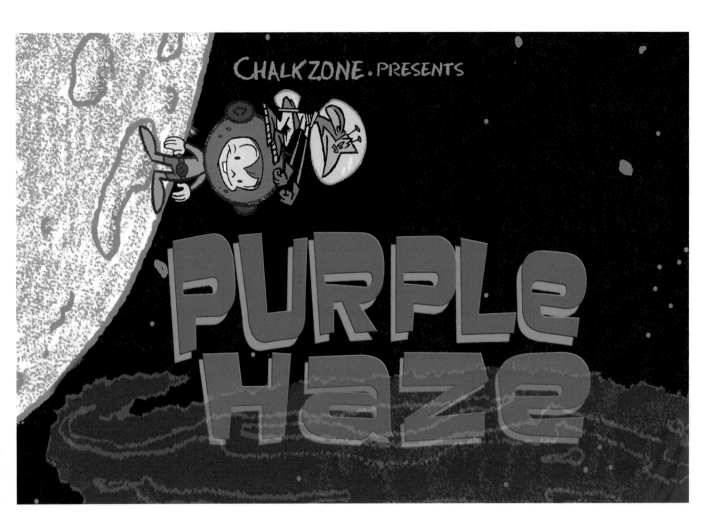

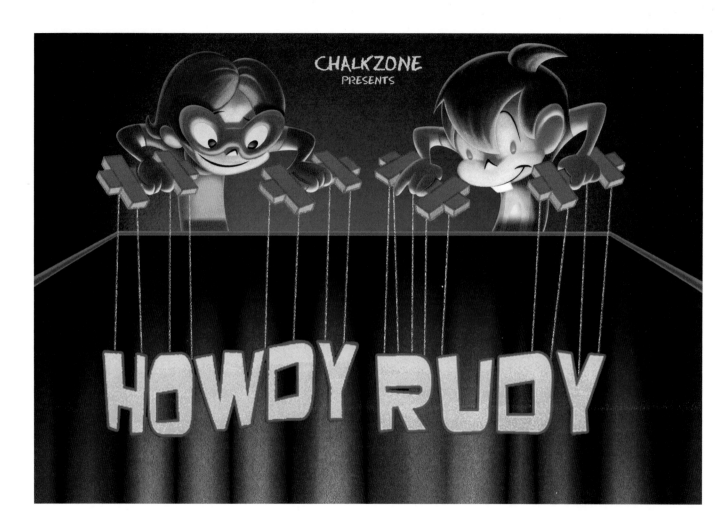

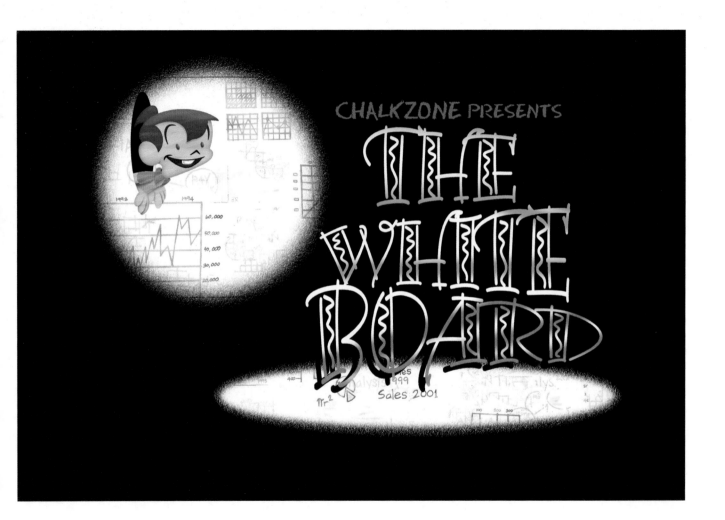

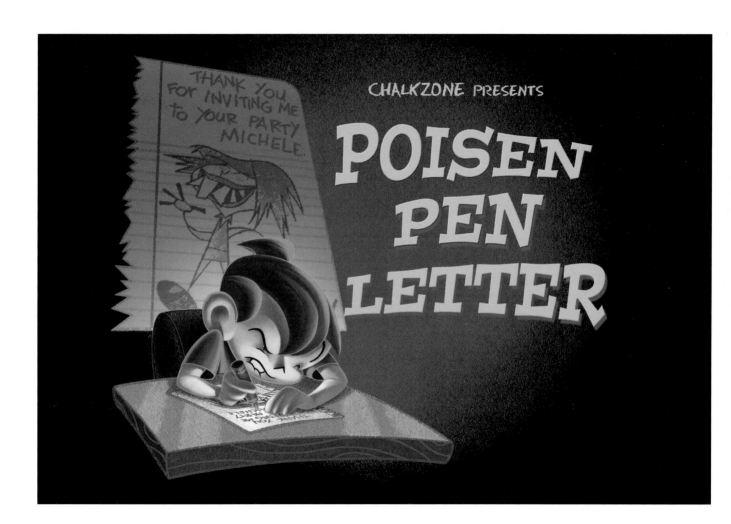

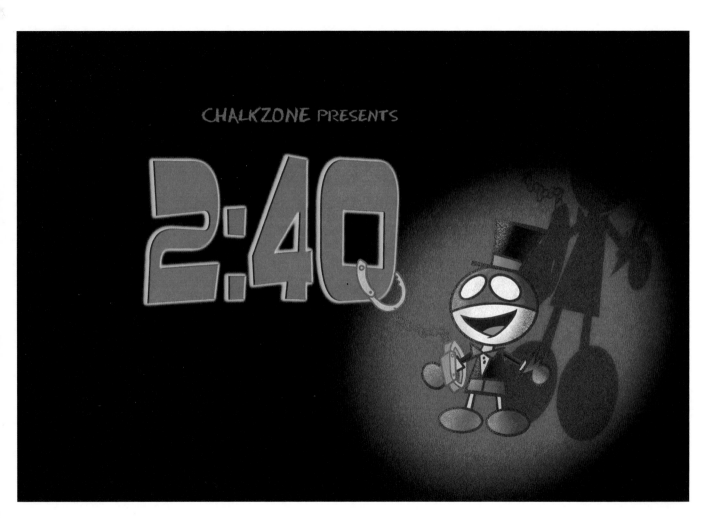

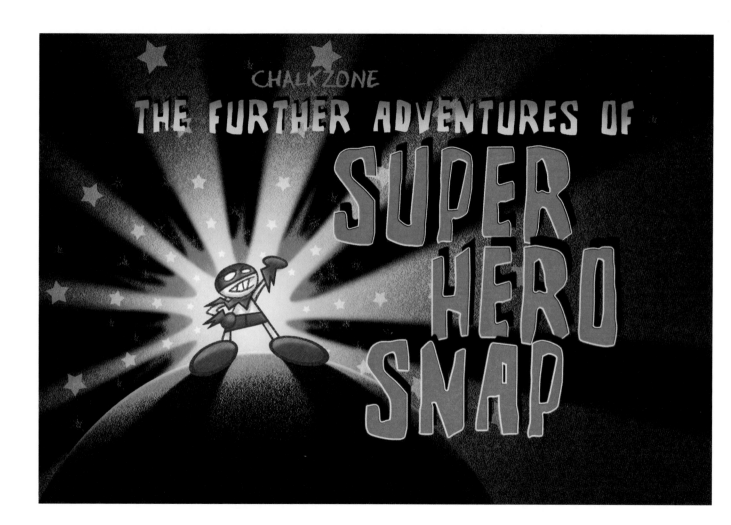

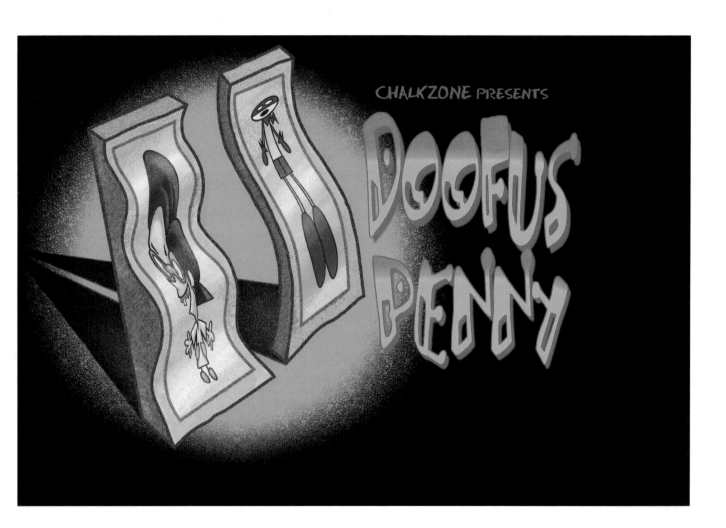

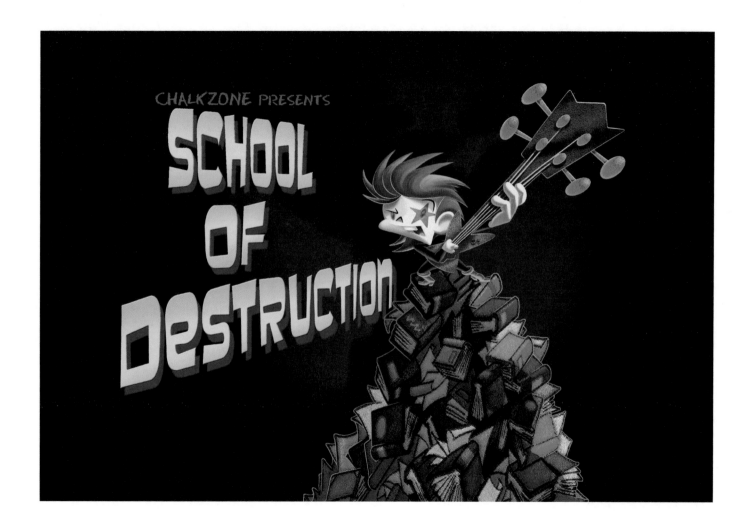

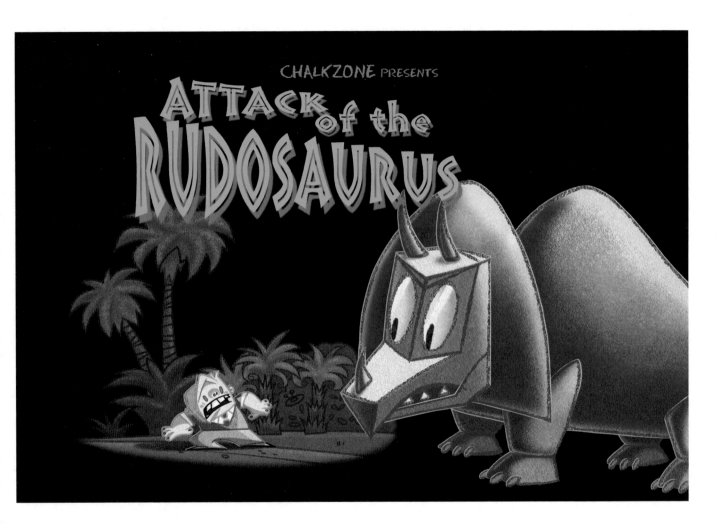

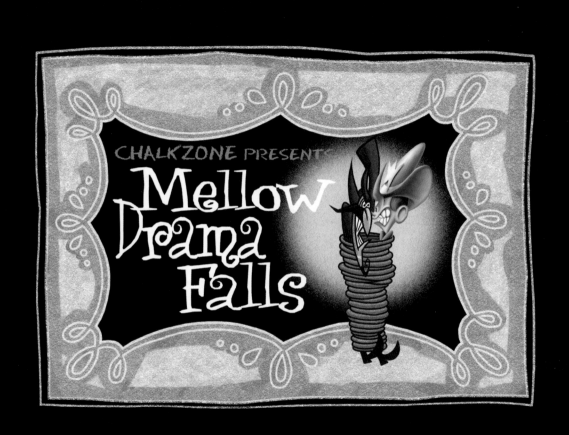

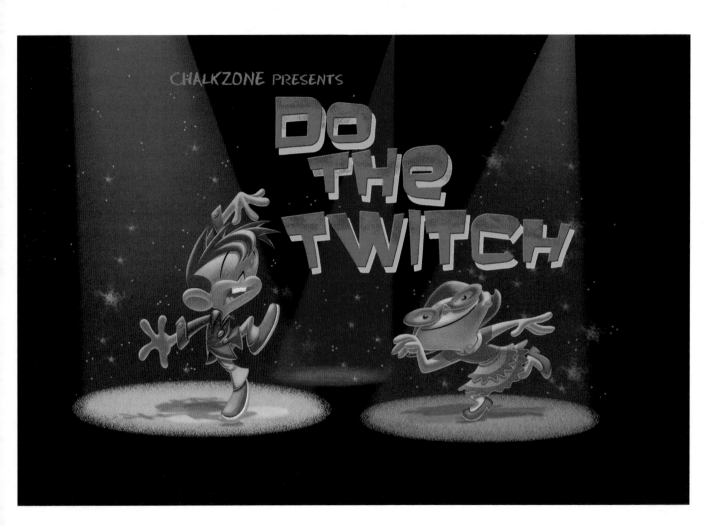

My Life as a Teenage Robot

2003-2006

Created by Rob Renzetti
Art direction by Alex Kirwan
Title card art by Joseph Holt

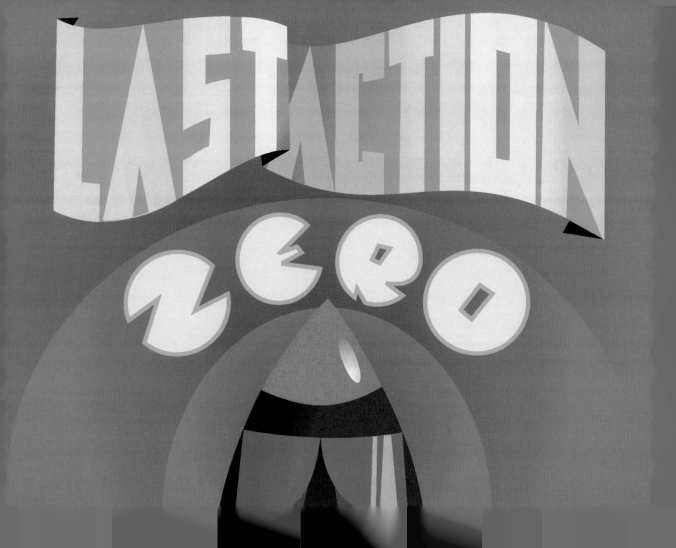

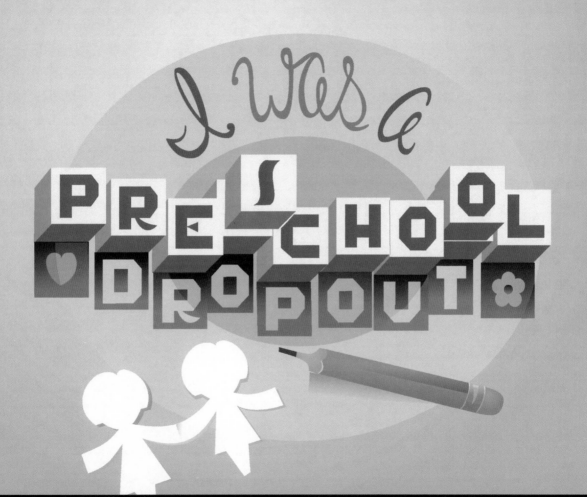

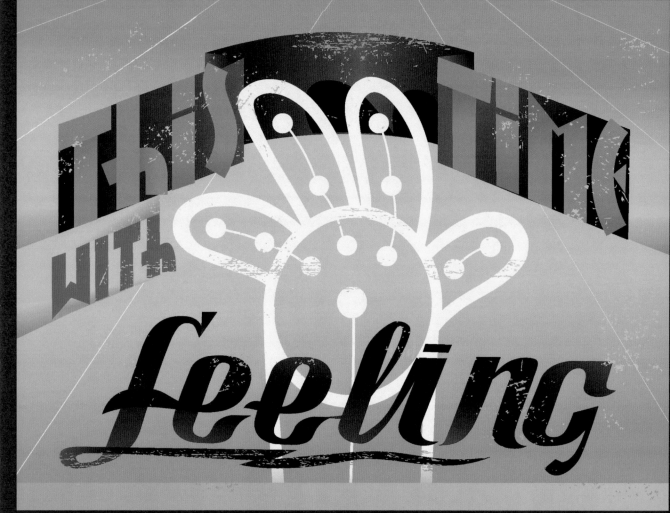

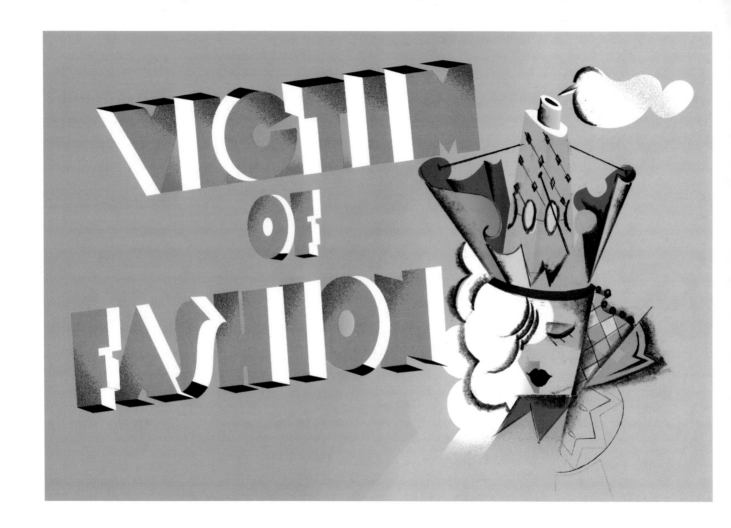

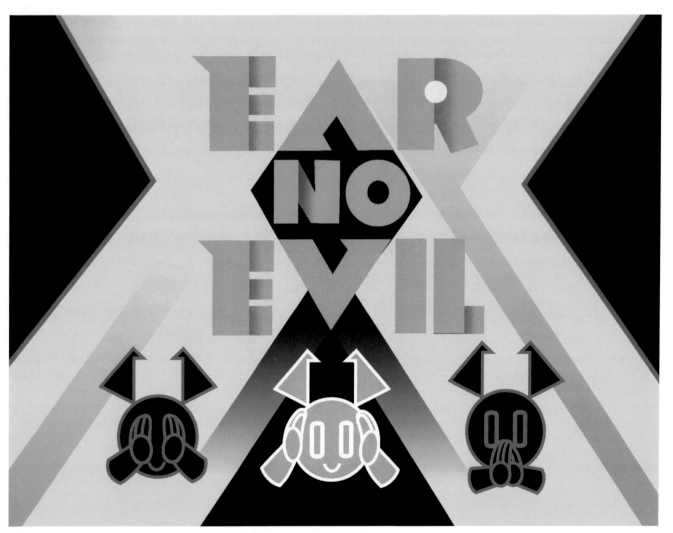

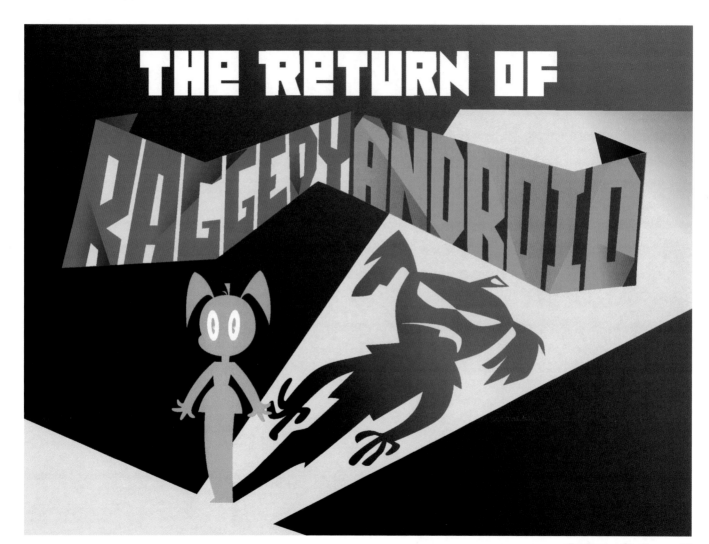

THE RETURN OF
RAGGEDY ANDROID

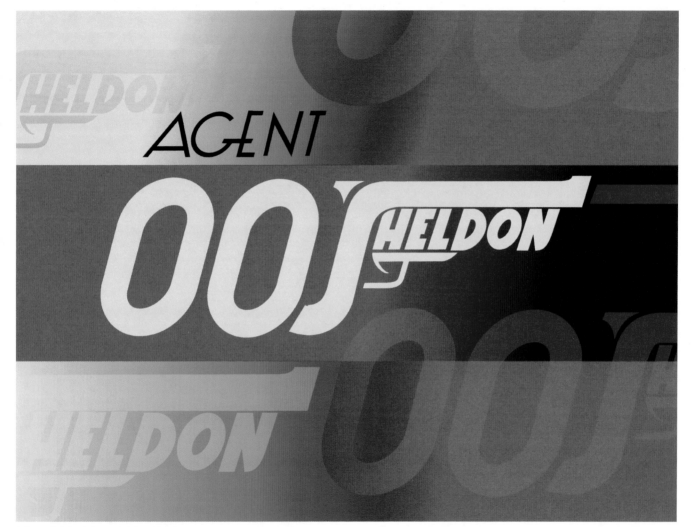

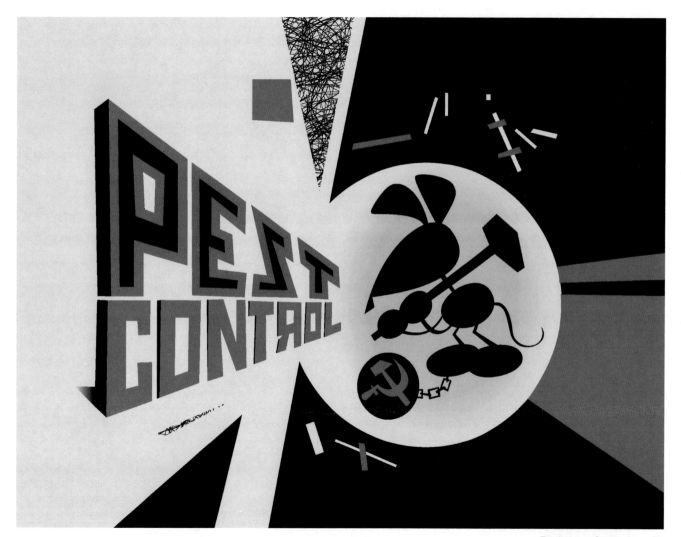

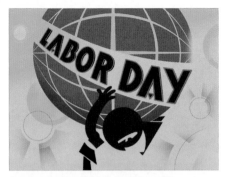

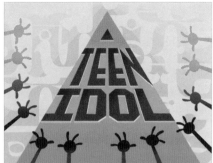

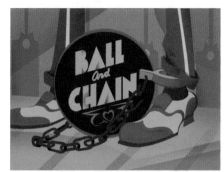

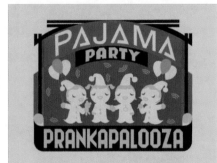

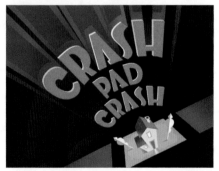

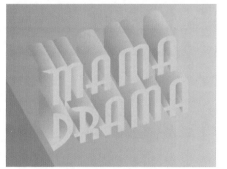

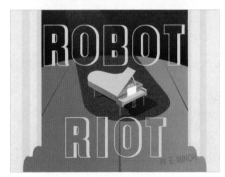

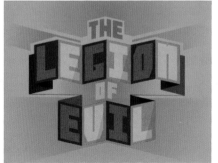

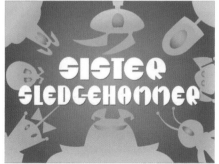

Wow! Wow! Wubbzy!

2006-2010

Created by Bob Boyle
Title card art by
Steve Daye, James Burks,
Paige Pooler, Don Fuller, Bob Boyle

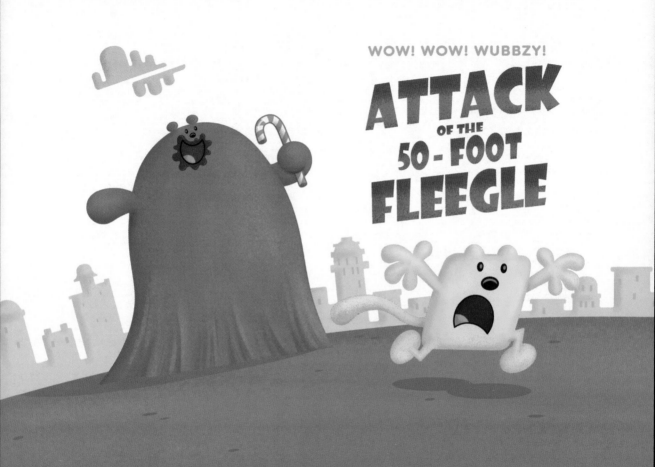

WOW! WOW! WUBBZY!

GOO
GOO
GRIEF!

WOW! WOW! WUBBZY!

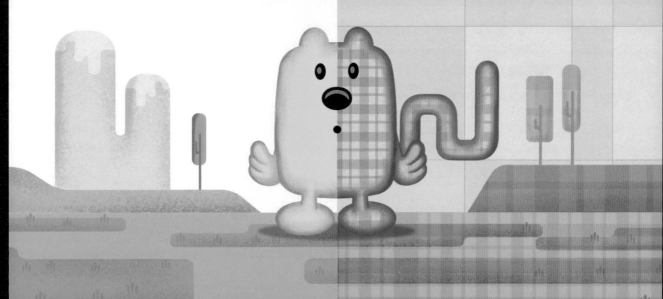

WOW! WOW! WUBBZY!

THE GRASS IS ALWAYS PLAIDER

WOW! WOW! WUBBZY!

EVERYTHING'S COMING UP WUBBZY

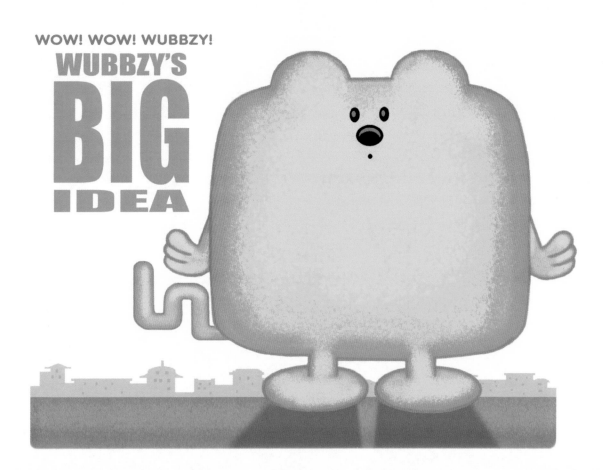

THE NASTY NOSE

WOW! WOW! WUBBZY!

WHAT WOULD WUBBZY DO?

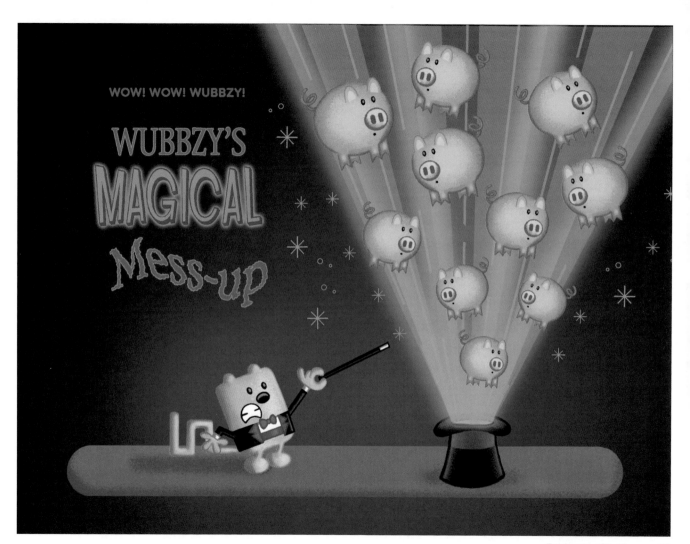

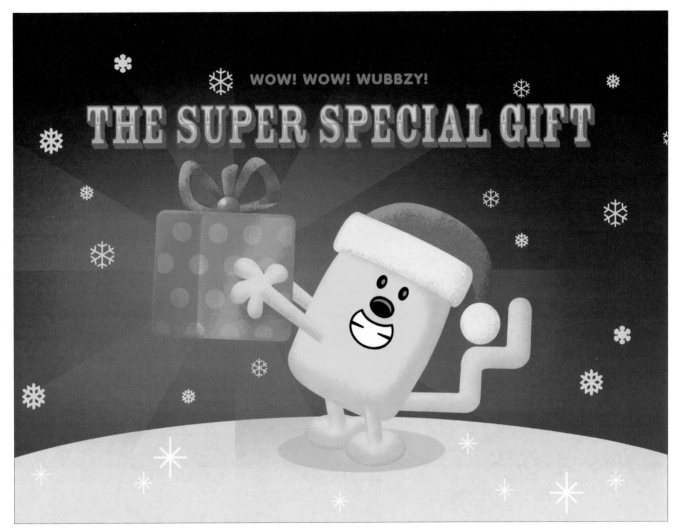

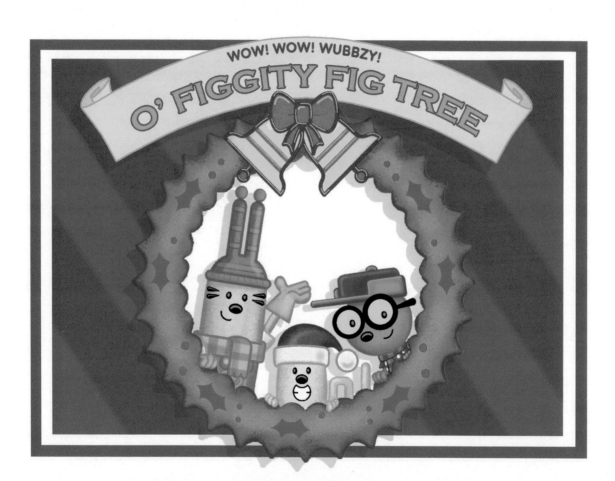

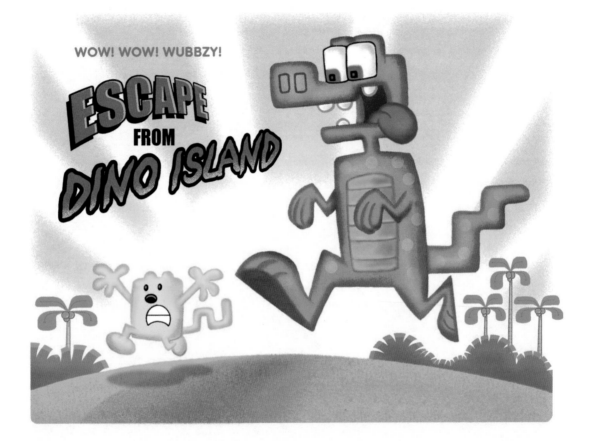

THE WUBBZY SHUFFLE

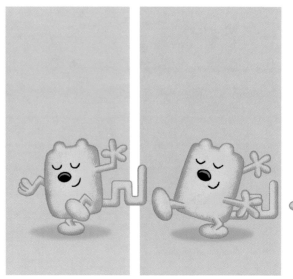
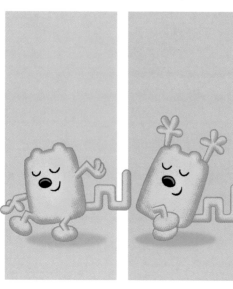

WOW! WOW! WUBBZY!

DAIZY'S
HAIR
SALON

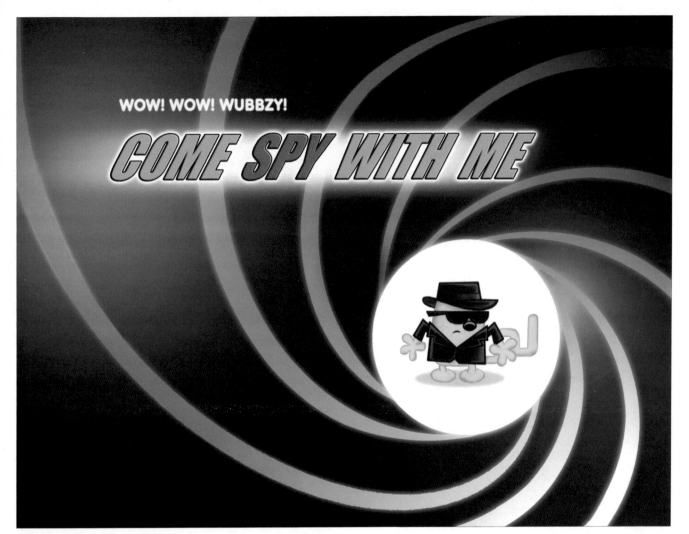

WOW! WOW! WUBBZY!

CUPID'S LITTLE HELPER

WOW! WOW! WUBBZY!

MR. VALENTINE

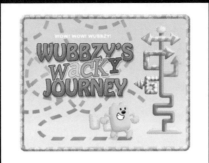

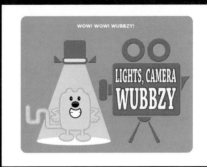

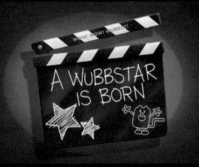

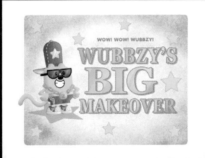

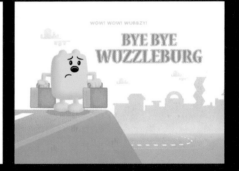

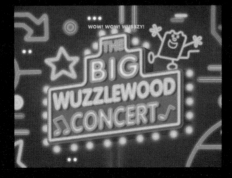

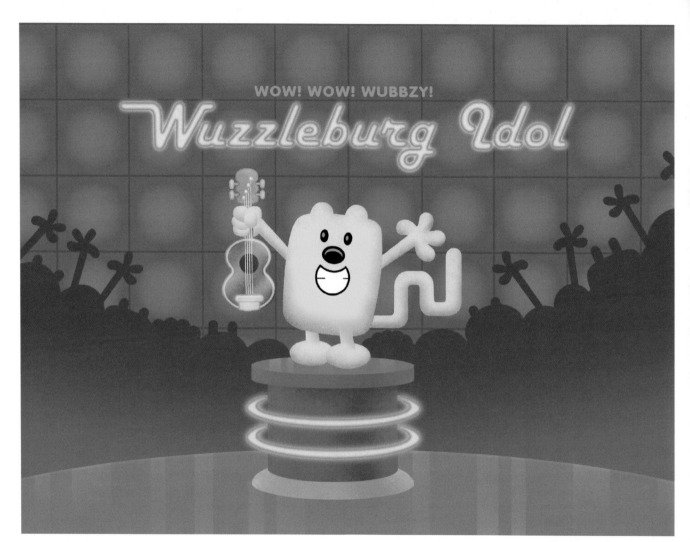

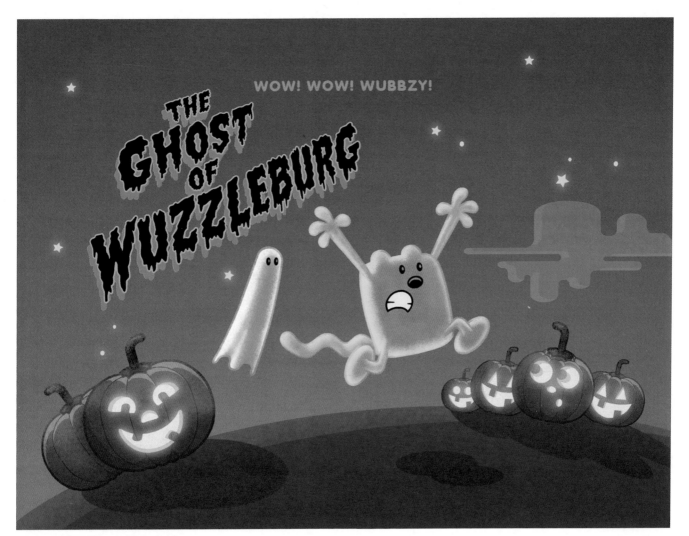

Random! Cartoons
2008-2009

Created by Fred Seibert
Title card art by
Adam Muto, Doug TenNapel, G. Brian Reynolds,
Russ Harris, Lincoln Peirce, Niki Yang,
Bill Plympton, Pendleton Ward, Paul Linsley

TWO WITCH SISTERS

Created and Written by **Niki Yang**

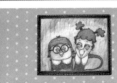

Directed By **Niki Yang**

THE END
Made in Hollywood USA

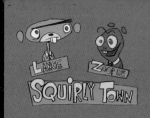

SQUIRLY TOWN

CREATED & WRITTEN BY **DOUG TENNAPEL**

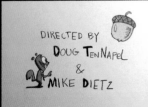

DIRECTED BY **DOUG TENNAPEL** & **MIKE DIETZ**

THE END
MADE IN HOLLYWOOD, U.S.A.

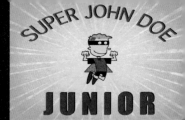

SUPER JOHN DOE JUNIOR

created & written by **LINCOLN PEIRCE**

storyboard by **FRED GONZALES**

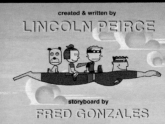

directed by **BRIAN HOGAN**

THE END
made in Hollywood, USA

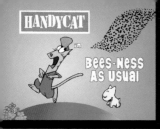

HANDYCAT in
BEES-NESS AS USUAL

CREATED AND WRITTEN BY
G. BRIAN REYNOLDS & RUSS HARRIS

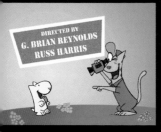

DIRECTED BY
G. BRIAN REYNOLDS
RUSS HARRIS

THE END
Made for Hollywood, USA

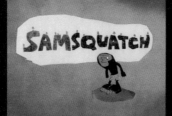

SAMSQUATCH

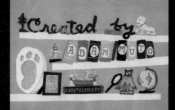

Created by ADAM MUTO
CRYPTOZOOLOGY

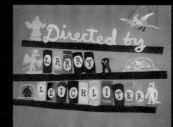

Directed by LARRY LEICHLITER

THE END
Made in Hollywood U.S.A.

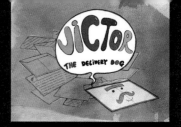

VICTOR THE DELIVERY DOG

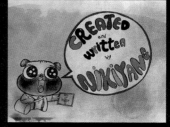

CREATED and written by NIKIYANG

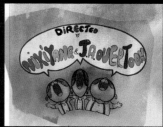

DIRECTED by NIKIYANG & J.R. OVERTOONS

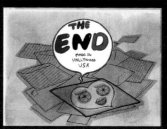

THE END
MADE IN HOLLYWOOD USA

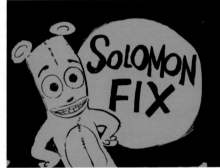

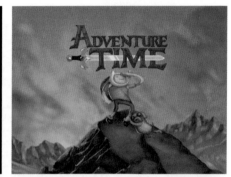

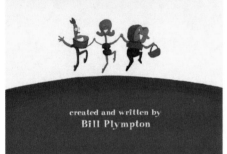

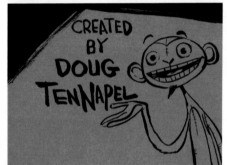

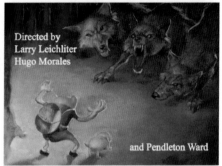

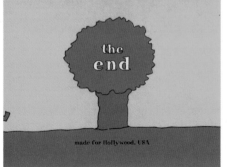

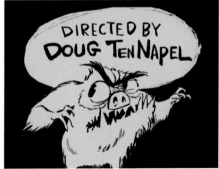

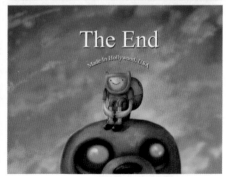

The Meth Minute 39
& Nite Fite
2007-2008

Created by Dan Meth
Title card art by Dan Meth

THE
METH
MINUTE³⁹

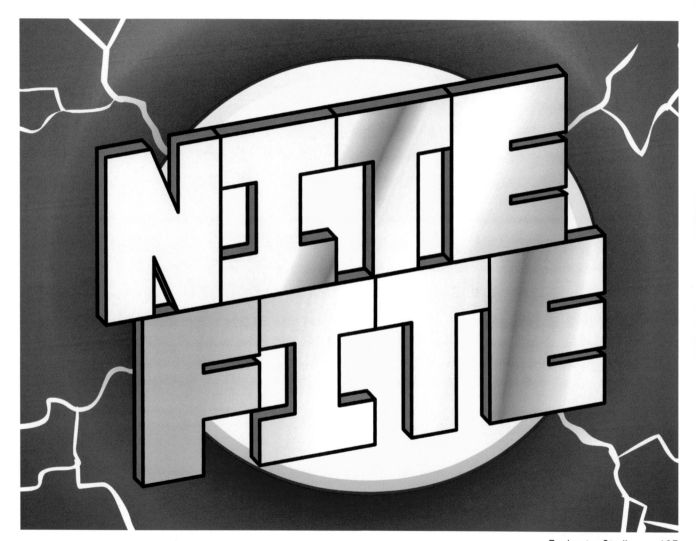

Ape Escape Cartoons

2009

Title card art by Karl Toerge

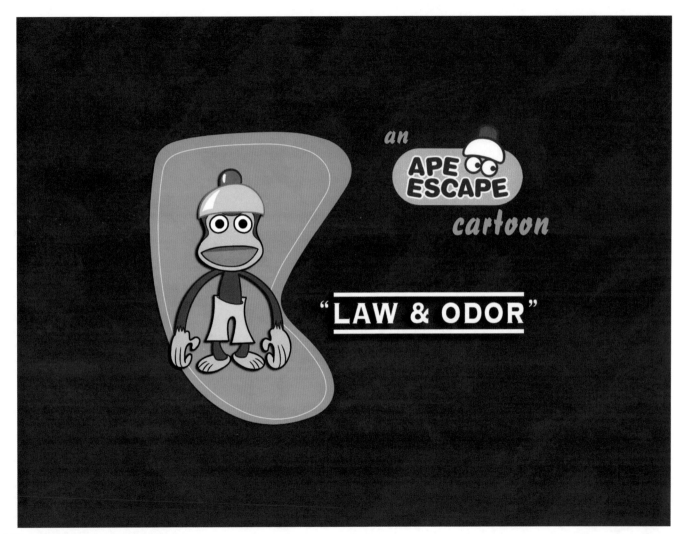

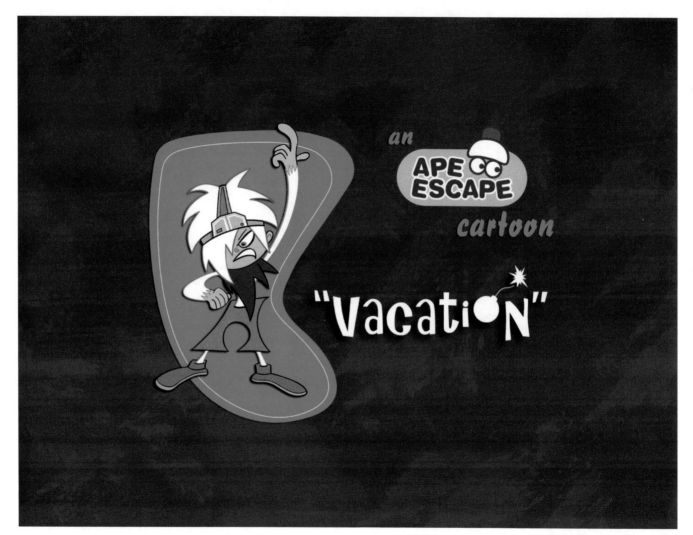

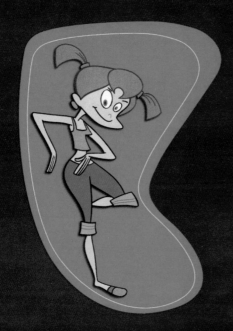

an **APE ESCAPE** *cartoon*

"APE DATE"

Fanboy & Chum Chum

2009-2010

Created by Eric Robles
Title card art by
Steve Lambe, Chad Woods, Patrick Morgan,
Roman Laney, Eric Robles

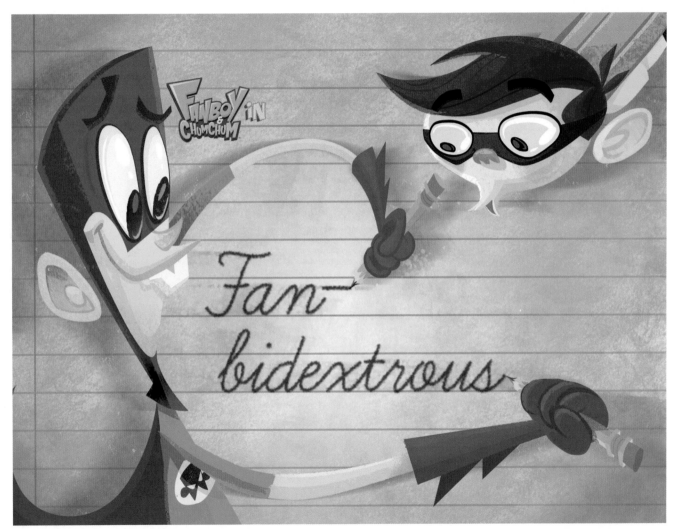

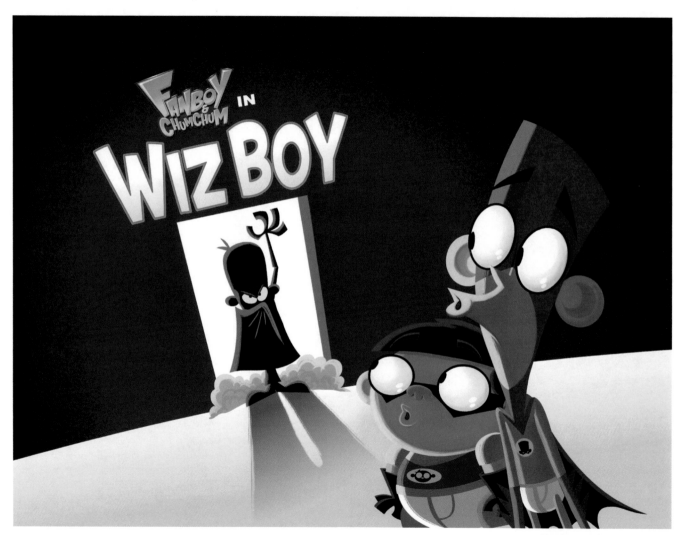

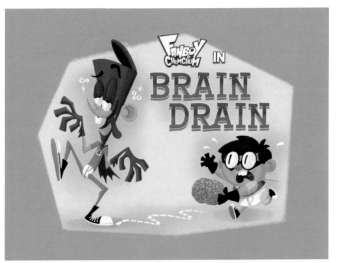

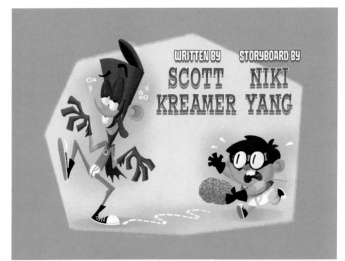

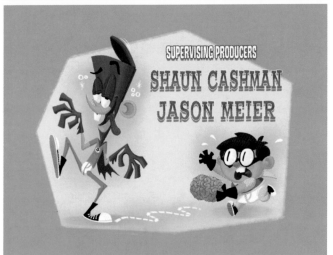

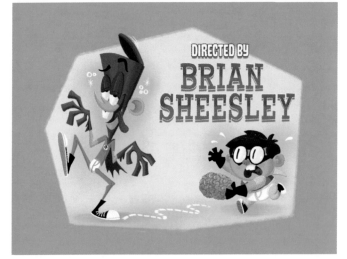

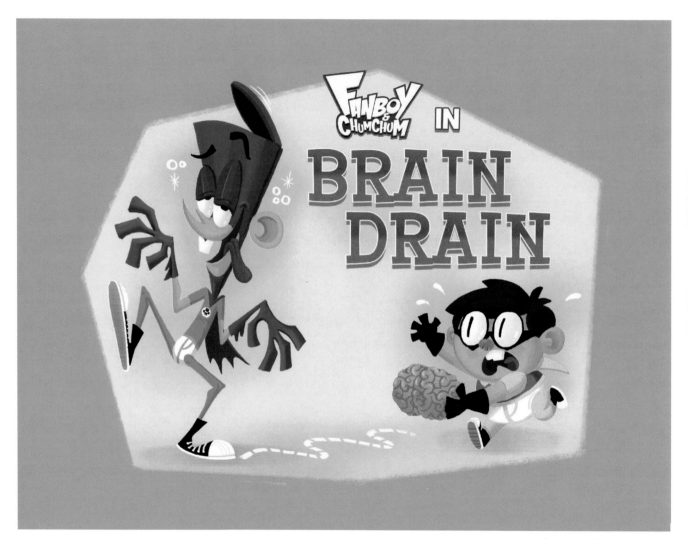

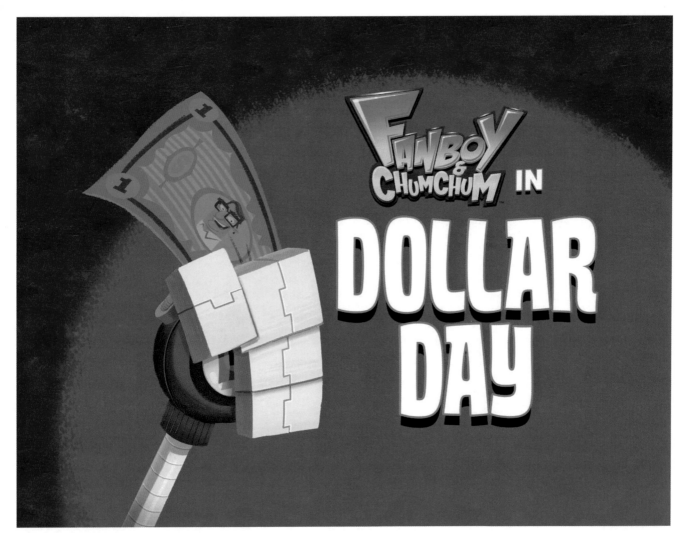

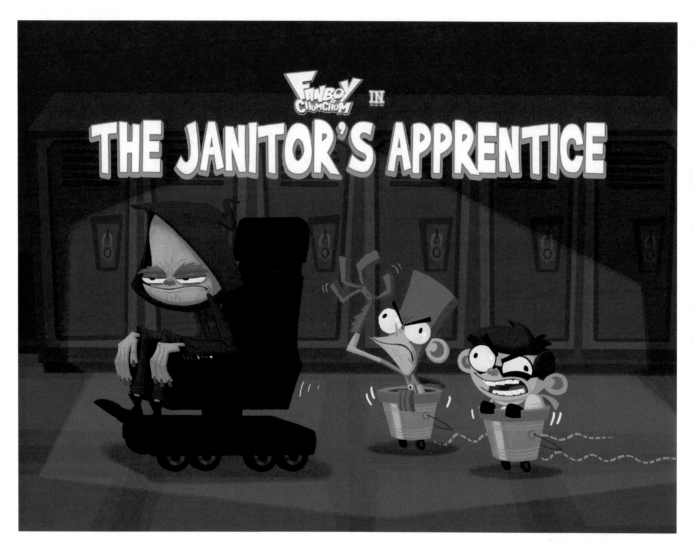

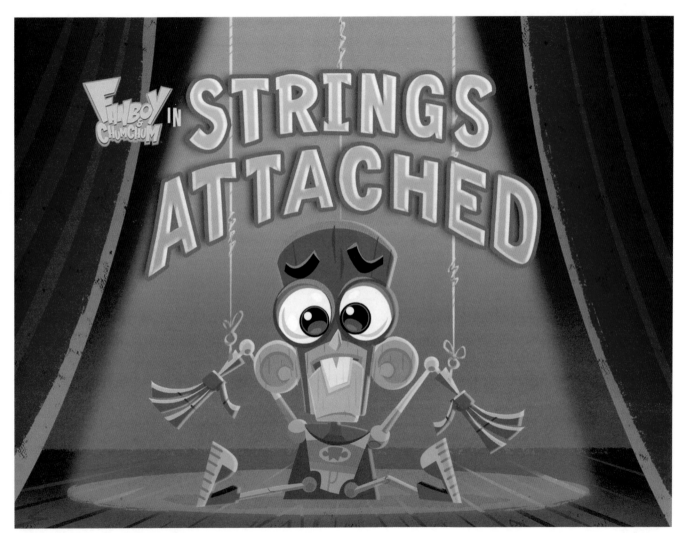

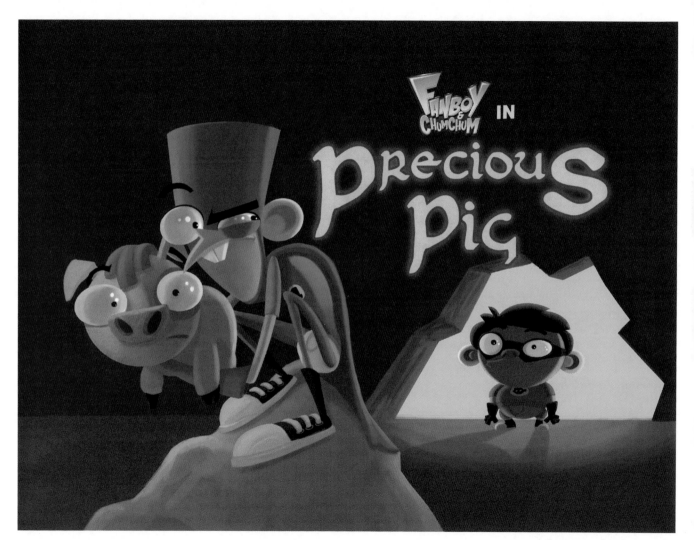

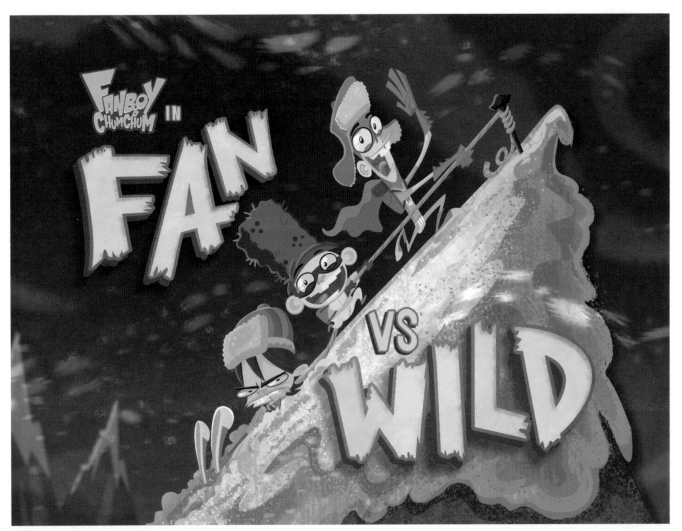

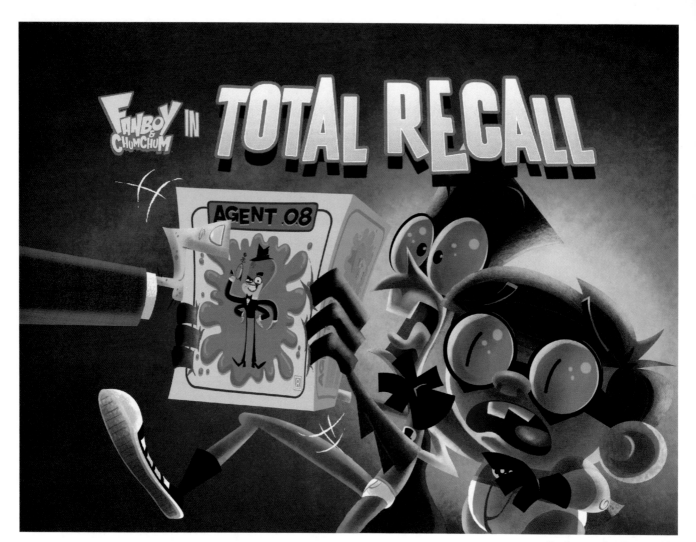

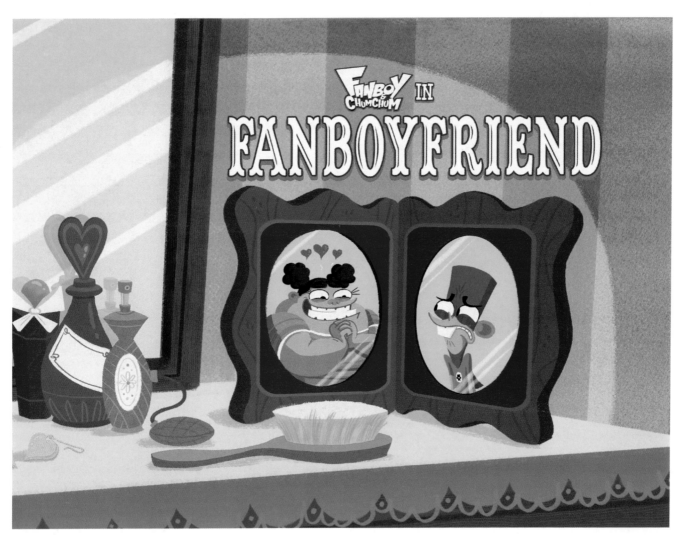

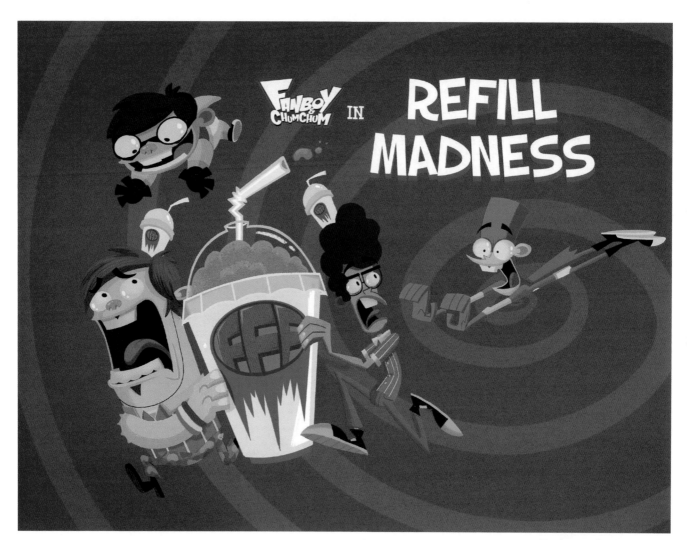

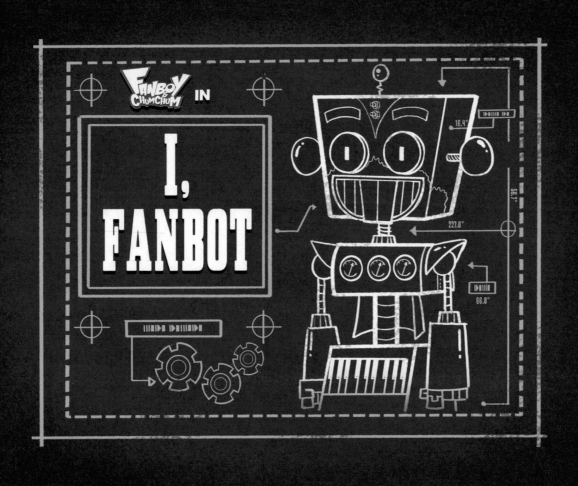

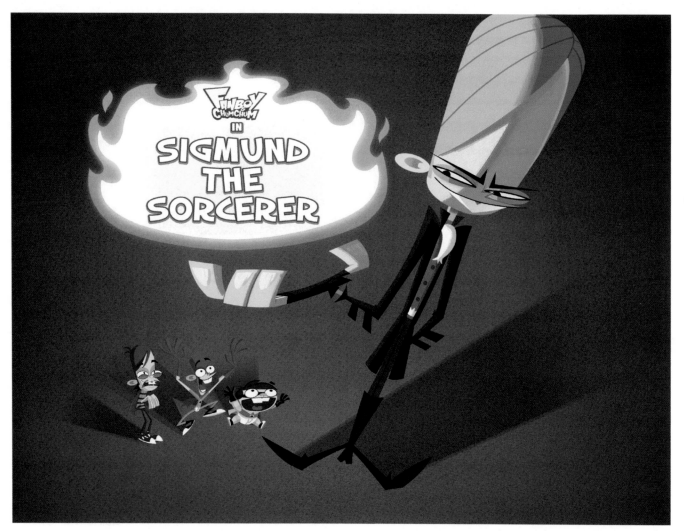

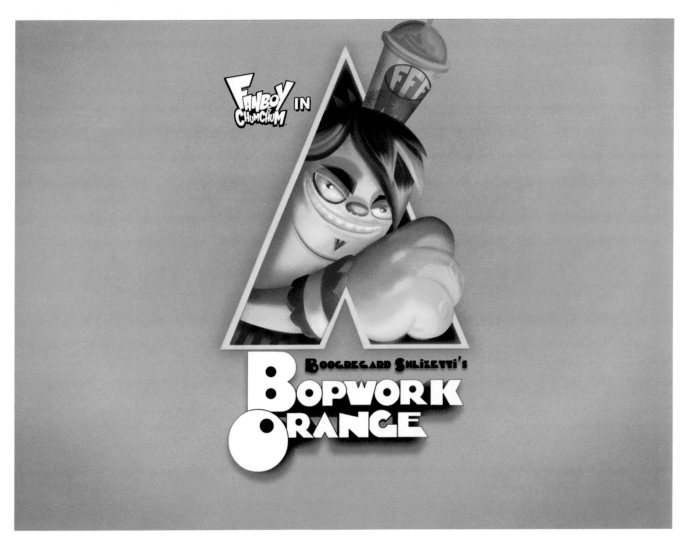

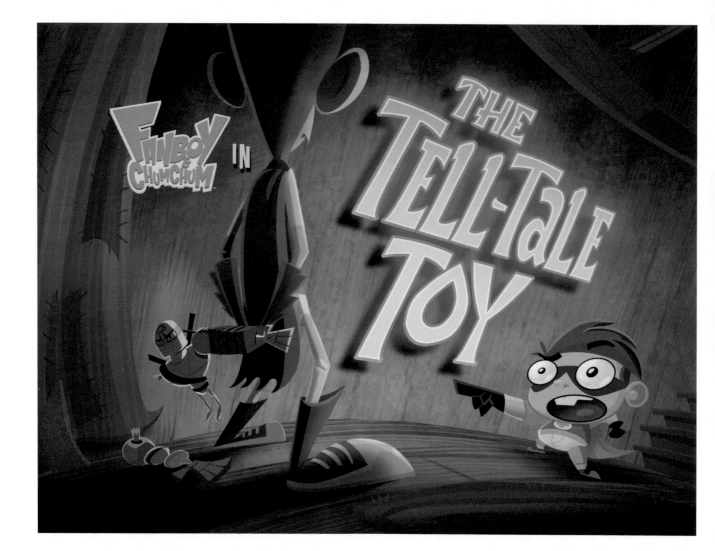

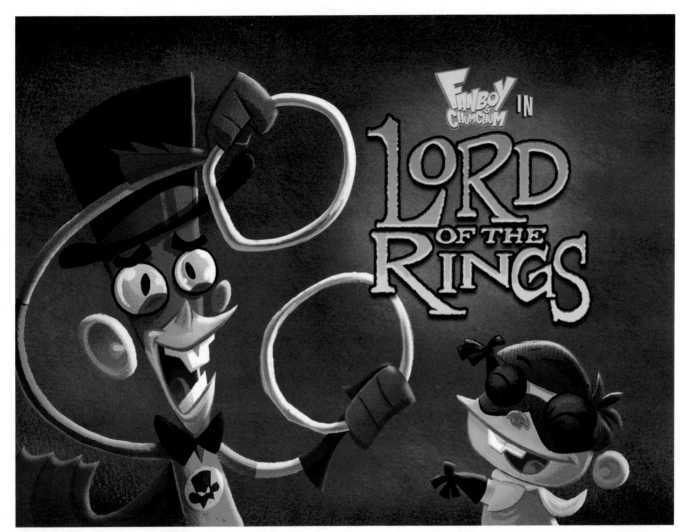

Adventure Time
2010

Created by Pendleton Ward
Title card art by
Phil Rynda, Paul Linsley, Nick Jennings

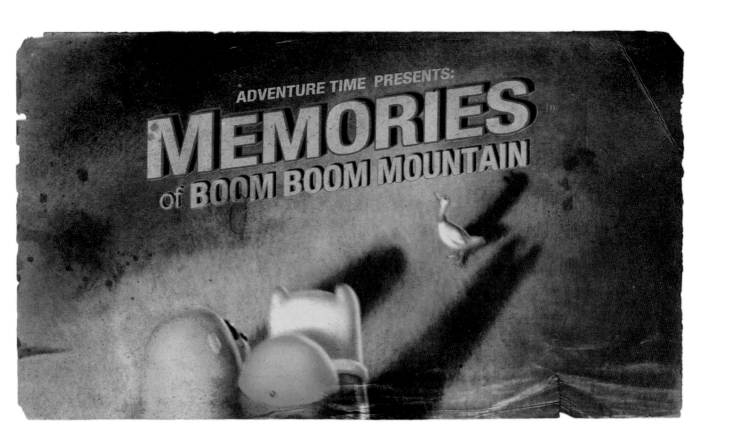

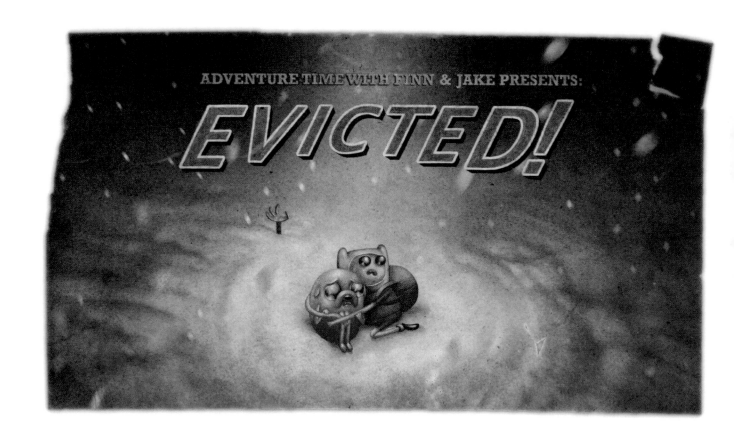

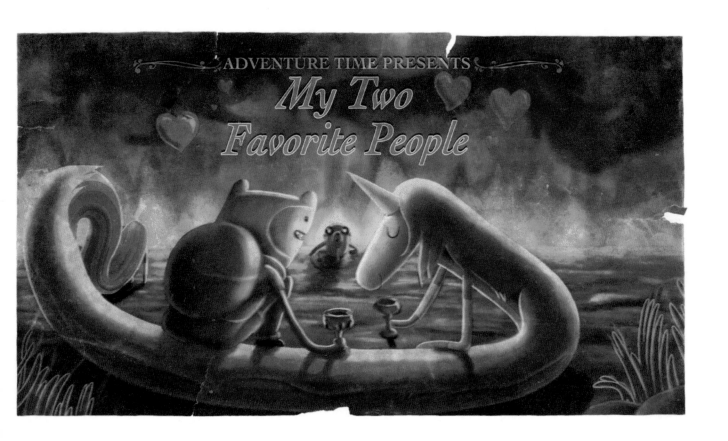

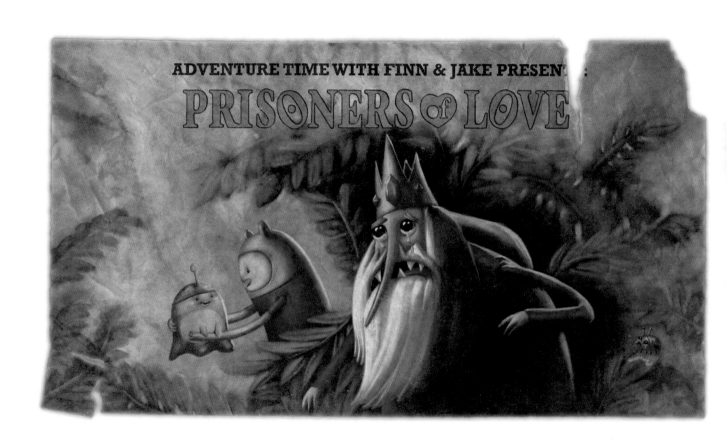

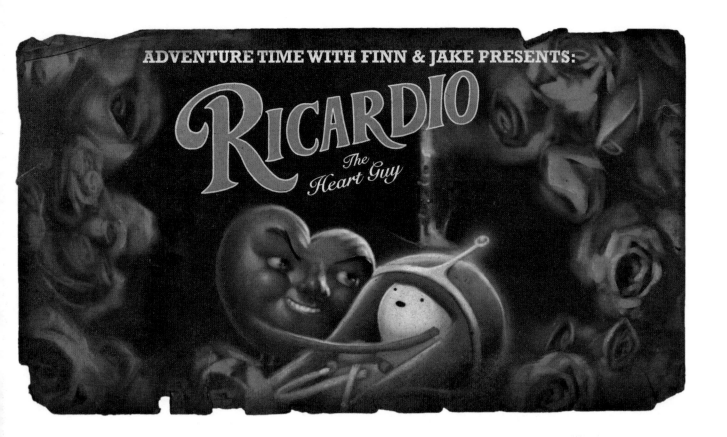

ADVENTURE TIME WITH FINN & JAKE PRESENTS:

SLUMBERPARTY PANIC

OOO PUBLICATION

25c

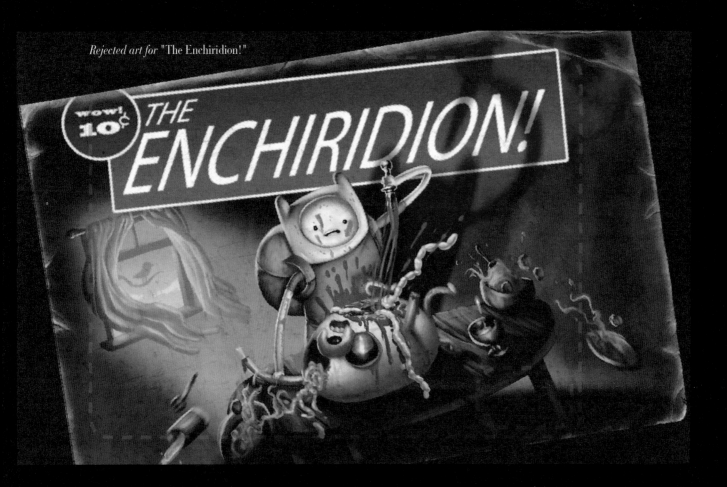

Rejected art for "The Enchiridion!"

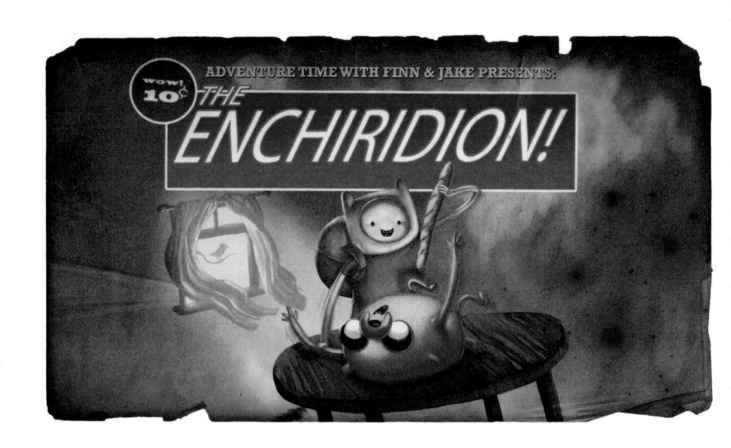

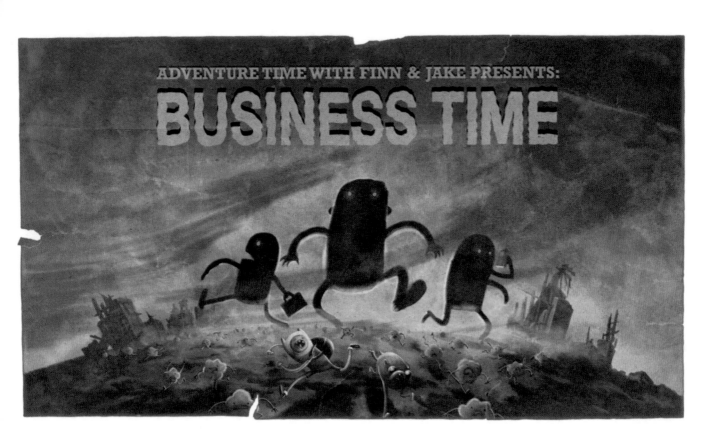

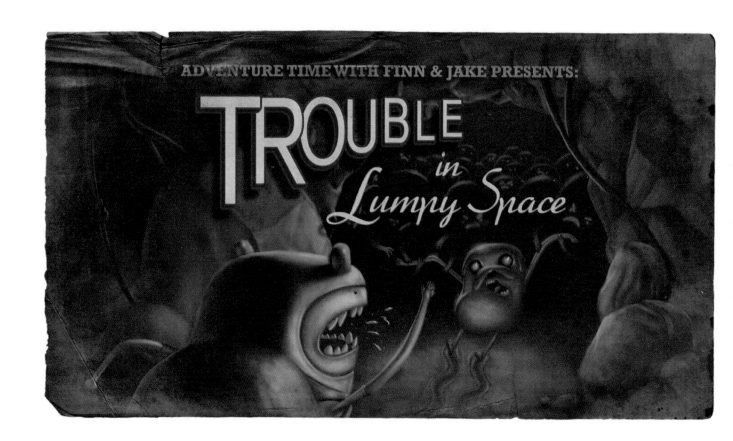

ADVENTURE TIME WITH FINN & JAKE PRESENTS:

TROUBLE
in
Lumpy Space

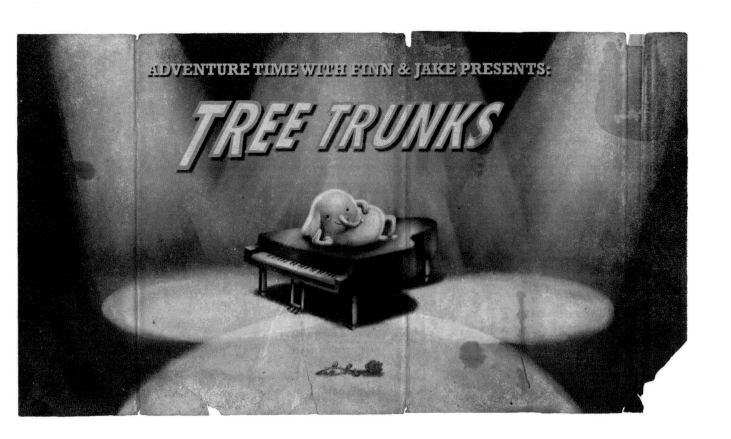

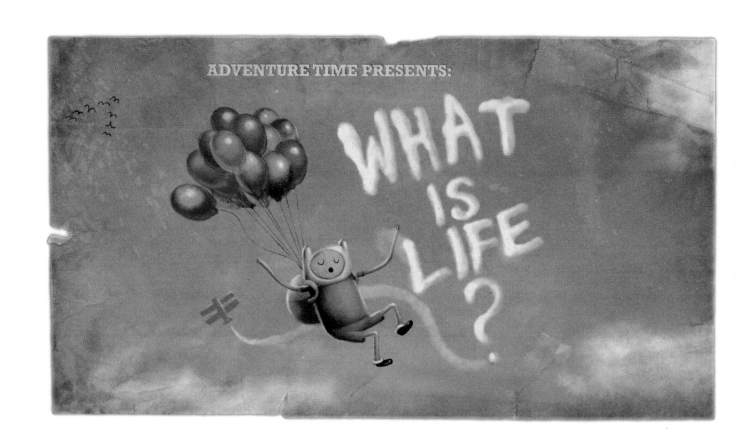

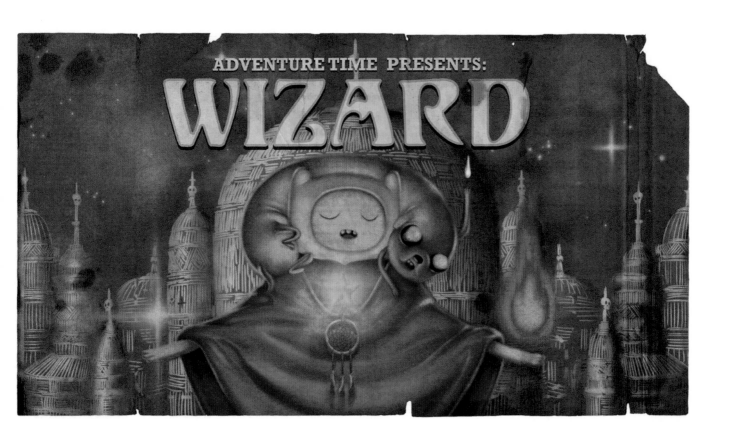

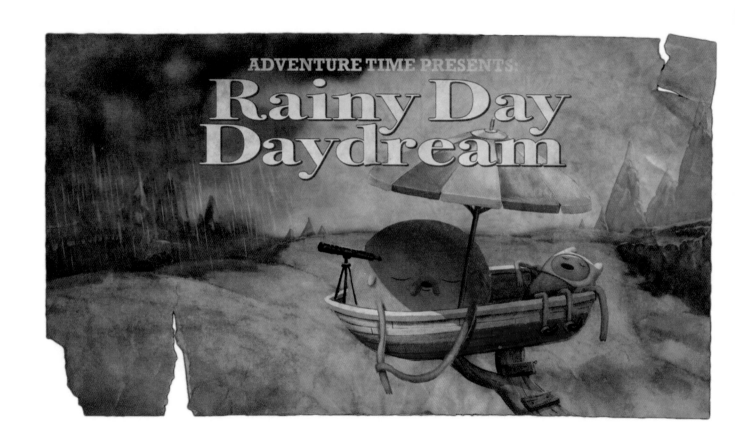

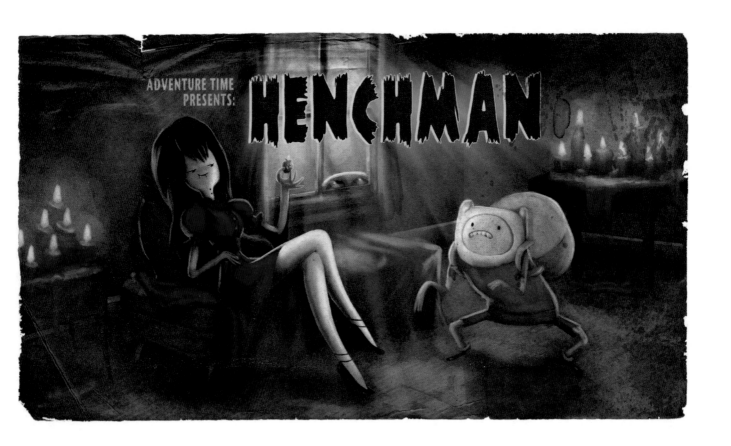

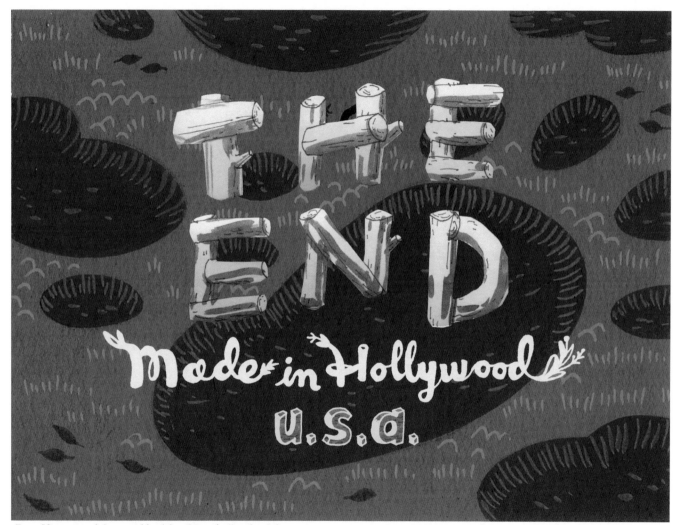

From "Samsquatch," created by Adam Muto for Random! Cartoons

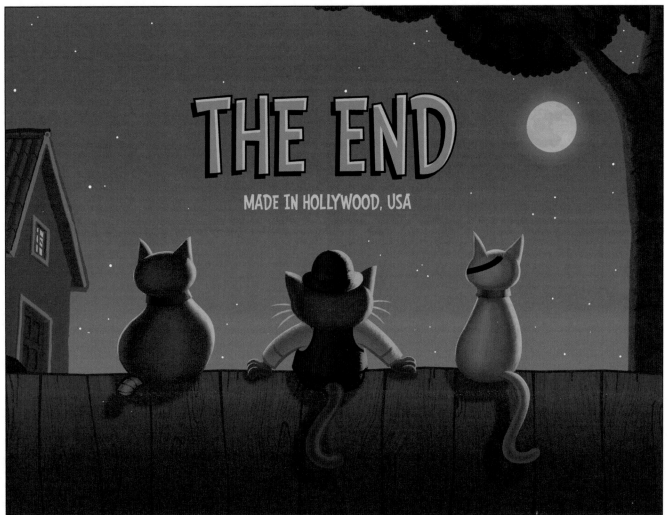

From "Thom Cat," created by Mike Gray for Random! Cartoons

Made in the USA
San Bernardino, CA
15 January 2013